FIELD NOTES

Photographs by Dianne Kornberg, 1992–2007

September 9 through October 24, 2007

The Art Gym, Marylhurst University

Marylhurst, Oregon

April 16 through May 31, 2008

Western Gallery, Western Washington University

Bellingham, Washington

Field Notes: Photographs by Dianne Kornberg, 1992–2007
Copyright © 2007 Marylhurst University
Photographs copyright © 2007 Dianne Kornberg
ISBN 0-914435-50-7
Library of Congress Control Number pending

This catalogue is being published on the occasion of the exhibition *Field Notes: Photographs by Dianne Kornberg, 1992–2007*, on view at The Art Gym, Marylhurst University, from September 9 through October 24, 2007, and at the Western Gallery, Western Washington University, April 16 through May 31, 2008. Terri M. Hopkins, director and curator of The Art Gym at Marylhurst University, organized the exhibition in collaboration with the artist Dianne Kornberg.

The Art Gym
Marylhurst University
17600 Pacific Highway
Marylhurst, Oregon 97036
www.marylhurst.edu

Preface

Dianne Kornberg's photographs place her in the company of all those who have taken the time—often a lifetime—to look at nature carefully. Kornberg grew up in Richland, Washington, was attracted to science, and began to collect bones, insects, and other remnants of nature in high school. She went on to study painting but turned to photography in the early 1980s. The medium has proven an elegant match for her intense observations.

This exhibition comprises nearly a hundred of Kornberg's photographs, of which seventy are reproduced on the following pages. *Field Notes: Photographs by Dianne Kornberg, 1992–2007* includes both gelatin silver prints and pigment inkjet prints. It begins with work from the artist's early *Bone Stories* series, progresses through her images of comparative-anatomy specimens from Reed College and photographs of carefully wrapped butterflies and moths from India, and concludes with her most recent focus on herbarium collections from the University of Washington Laboratories on San Juan Island in Washington state.

Kornberg has exhibited at many prestigious museums and galleries, including the International Center for Photography in New York, the House of Photography in Prague, G. Ray Hawkins Gallery in Los Angeles, the Princeton University Art Museum, Nohra Haime Gallery in New York City, Zolla/Lieberman Gallery in Chicago, the Seattle Art Museum, the Portland Art Museum, and the Tacoma Art Museum. She divides her time between Portland, Oregon, and Obstruction Island in the San Juan Islands.

Kornberg is one of the important photographers of her generation, and it is an honor to present a selection of her work over the past fifteen years for public enjoyment and consideration. We are very pleased that the exhibition will travel to the Western Gallery at Western Washington University, and we thank director Sarah Clark-Langager for making that possible. Collectors play an important role in an artist's career, providing financial support and intellectual encouragement. We appreciate the additional generosity of those collectors who are loaning work for presentation at both venues: Alexandra Hart, Greg Kornberg, Steven McGeady and Linda Taylor, Carla and Sam Pope, and George Stroemple.

This book joins more than fifty exhibition catalogues published by The Art Gym at Marylhurst University since 1980. It is The Art Gym's mission to promote public understanding of the work of contemporary artists of the Pacific Northwest. We are fortunate that Terry Toedtemeier agreed to write the essay on Kornberg's work. Toedtemeier is the curator of

photography at the Portland Art Museum. He is also a geologist and is recognized for his photographs of basalt formations in the West. As an artist who views the natural world with the knowledge of a scientist, he is in a unique position to discuss Kornberg's photographs and has crafted an essay that places them in the context of the history of photography. Designer John Laursen of Press-22 is well known as a book designer and in particular for producing books with the highest-quality reproductions of photographs and art.

Once again we thank the Regional Arts & Culture Council for providing substantial support for an exhibition and publication documenting the work of an Oregon artist. The Oregon Arts Commission and the National Endowment for the Arts also continue to acknowledge our work with support for our programming.

A number of private individuals have recognized the importance of this publication, and we thank them all for their generosity. In particular, we are greatly indebted to Steven McGeady and Linda Taylor and the McGeady Family Foundation for major financial support of this publication. We also could not have proceeded without the support of Jean Vollum, Kathleen MacNaughton, Leah Friedman, Tricia Savitt and Irene Eaton, James Leisy and Cynthia Kirk, William and Meredith Savery, John and Linda Tesner, and Alfred and Eileen Ono. We thank the Pacific Northwest College of Art and the Elizabeth Leach Gallery for their generous support of this project.

I have had the privilege of organizing this exhibition in collaboration with Dianne Kornberg and the pleasure of looking at many more photographs than we could include in this survey. One of a curator's true joys is the opportunity to study art with the artist at one's side. I hope that the exhibition and book will allow viewers and readers to share that experience. I thank Dianne Kornberg for the great care she has devoted to this project in all its complexity. Most important, on behalf of Marylhurst University and the larger community, I thank her for the art.

Terri M. Hopkins
Director and Curator
The Art Gym

Artist's Acknowledgments

I owe a great debt to the scientists and naturalists who collected, identified, and beautifully preserved the specimens that I use. It is their work that makes mine possible. For access to their collections, I would like to thank Dr. Marie Churney, Dr. Ed Florance and Lewis & Clark College, Dr. Steven Forbes and Portland State University, Dr. Craig Staude and the University of Washington's Friday Harbor Laboratories, and Reed College.

Thank you to the students and my colleagues at the Pacific Northwest College of Art for providing me with such a rich creative environment, and to the college itself for the many occasions of support while this work was under way. I am very grateful to the Helen Riaboff Whiteley Center for the residencies that made my work at the Friday Harbor Laboratories possible. I appreciate the essential, ongoing technical assistance with digital processes that Phil Bard has generously provided.

Over the years, Terry Toedtemeier has not only supported my work, but he and Prudence Roberts have also provided important counsel and friendship. I am honored to have his insightful essay included in this catalogue. I appreciate the care that John Laursen has taken to design a book that presents my work with such integrity and elegance. It has been my good fortune to work with Jim Haeger and Bruno Amatter, masters of the art of reproduction.

That we have been able to realize a publication of this quality and scope is due to the generosity of Steven McGeady and Linda Taylor, whose faith in my work is humbling. I would also like to express my deep gratitude to all those who supported the catalogue through donations and by purchasing the two special-edition prints and the limited edition of this book.

Marylhurst University and The Art Gym, with unerring vision, have encouraged and promoted regional artists for more than a quarter of a century. I am honored to be one of that number.

For his support of my life as an artist, I dedicate this book to Jack Hart.

Dianne Kornberg

Contents

Still Life:
Objects, Apprehensions, and the Photography of Dianne Kornberg

Terry Toedtemeier

Although the lyrics from a song by Willie Nelson may seem an unlikely reference, "Still is still moving to me" is an apt description of Dianne Kornberg's appreciation for the preserved remains of animal and plant life that she has so rigorously and painstakingly photographed for more than fifteen years. The mysterious beauty of bones, the delicacy of preserved insects, dried algae, pressed plants, and other elements of the natural world fascinate her. Beyond this, her work is a meditation on the very act of looking at such specimens and the ways in which they have been presented, labeled, and categorized. In search of a more profound resonance, Kornberg has brought the essence of these still objects back to life. At the same time, her own deepening curiosity about photographic processes has led her out of the darkroom and into the new digital age.

Kornberg began her exploration of botanical and biological collections when, as she puts it, "a huge gift landed in my lap." One day one of her students alerted her to the fact that during a facility cleanup at Reed College, a substantial collection of comparative-anatomy specimens had turned up in a janitor's storeroom. The specimens, still in their original storage boxes and envelopes, had lain undisturbed for half a century. Kornberg quickly gained access to this collection, the first of many she has investigated.

The photographs that have resulted explore the interplay between two kinds of archival evidence. First, of course, there are the specimens themselves, but in addition there are the trappings that document the process of collecting and categorizing: the boxes, labels, wrappings, mounts, and bits of string and tape. These materials, like the objects they protect or identify, are now relics as well, testament to a time when such collections were assembled for education and for pleasure. Though separated from their original purpose, these objects have served as visual treasure troves for Kornberg. The beauty of the bones and bugs, feathers and leaves that she presents in her elegant photographs is made all the more fascinating by the visual context that surrounds them and identifies them as objects of scientific study. Further, these images link Kornberg to a long history of photographs that combine aesthetic concerns with scientific ones.

The world's first book with photographic illustrations was a botanical reference volume titled *Photographs of British Algae—Cyanotype Impressions*, published in 1843. Its author, photographer Anna Atkins (1799–1871), was a colleague of William Henry Fox Talbot, inventor of the negative-positive photographic process, and of Sir John Herschel, a scientist and pioneering photographic chemist who introduced the word "photography" into the English language. Herschel was the inventor of the cyanotype, a remarkably simple process that produced blue photographic prints using iron salts. The simplicity and permanence of this state-of-the-art process appealed to Atkins, who used it to create photograms—cameraless prints—made in direct contact with her botanical specimens.

In her carefully arranged compositions, Atkins made visual records that were both factual and elegant, blending her deep affection for botanical forms with her fascination with the newfound art of capturing their images. In similar fashion, Kornberg blends her love of archival evidence with her curiosity about the myriad possibilities of imaging technologies. But what she also shares with Atkins and later photographers is her desire to get at the heart of the collections themselves—the scientific breakthroughs that led academics and amateurs to assemble such specimens in the first place. Which leads us back to Charles Darwin.

At about the same time that photography was being invented, Darwin (1809–1892) was formulating his concepts of natural selection and of the evolution of life on Earth. The intellectual platform upon which Darwin's ideas were based was quite literally grounded in hard-won understanding of the vastness of geologic time. This concept stood in marked contrast with religious dogma and its belief in a spontaneous moment of divine creation of the Earth and all its inhabitants. By Darwin's time, Scottish geologists James Hutton and Sir Charles Lyell had refuted a literal interpretation of Scripture and had established that the Earth was not only vastly older than the Old Testament's Book of Genesis could accommodate, but also that it had been and continued to be in a state of uniform and constant change.

Darwin picked up the arguments of Hutton and Lyell, which were based on the study of geologic strata and the evidence of fossil remains of extinct plants and animals. Darwin proposed that, through the course of the Earth's history, all species had evolved from a lineage of common ancestors. This theory of evolution ignited a revolution in human thought, a sweeping reassessment that fostered a profound appreciation for the relatedness of all forms of life. A key element in the intellectual climate of the era was a fundamental belief in the value of direct observation, and in biology this meant close study of the relationships between specimens. In these connections lay the genesis of new theories. What, for example,

might it mean that seemingly very different sorts of animals share remarkably similar types of bones put together in much the same way? How might the imagination embrace the fossil forms of ferns identical to the plants adorning one's parlor, identical save for the fact that the fossil fronds were ten times larger?

Photography played a critical role in creating graphic taxonomies that were at once scientific and aesthetic evidence. While Kornberg's forebears may have been primarily concerned with documentation, the images they produced also constitute a rich artistic history. Of particular note is *Urformen der Kunst*, published by the German artist Karl Blossfeldt (1865–1932) in 1928. A seminal study of the abstract beauty of plant forms, this work is considered one of the most important and influential photography books of the twentieth century. Like Atkins and Blossfeldt, Kornberg has navigated a world where scientific discovery and artistic inspiration share an appreciation of form.

In the many statements that people make in response to Kornberg's art, a common thread emerges in recognition of the deeper mysteries that haunt these photographs:

There's a beautiful strangeness to her work.

Her subjects take on a new life—they dance, they reach gracefully out to us, they seem to be still alive.

The photographs are at once macabre and beautiful.

These aren't just a bunch of pretty, dried flowers—her choices are unusual, challenging.

She has a wonderful interest in morphology and structure.

There's an intellectual and anatomical twist to her work, an energy not unlike watching dinosaurs dance.

*The compositions she creates surely embody the notion of mortality—*nature morte—*that is at the heart of the still life.*

"Compositions that embody mortality." This formulation gets us close to the fusion of beauty and bittersweet irony in Kornberg's work. There is a disquieting tension in the simultaneous apprehension of loveliness and death. Understandably, it is difficult to articulate. On the one hand, the word "apprehension" connotes awareness and understanding; on the other, it implies fear and foreboding. Bones and dried plants, beautiful though they may be, remind us of the inescapable tenuousness of life and offer no solace for its passing. Yet there's the reality of it. Life is a procession of living forms, and in their residues—bones and

leaves, feathers and insect wings—lie the material shadows of a succession of generations. The framework of our understanding of life, the experience of our own lives, is simultaneously a defining consciousness and an infinitesimally small part of the whole of it. Deprived of physical immortality, we try to create works that will outlast us and that, in a time beyond ours, will possibly serve to kindle an understanding and appreciation of who we were. Unconsciously, bones and fossils serve a parallel purpose, and their forms are imbued with the richness of their being. To explore their mystery and beauty brings us to a deeper appreciation of existence—of birth, life, and, inevitably, our own passing. It is this understanding that Kornberg ultimately seeks in her own compositions.

Kornberg herself is awed by the complexities of the materials she has photographed and by her own discoveries as she has worked with them. "When you look at things and they just take your breath away, it's a very edgy kind of experience," she notes. The collections themselves demand a lot of her. Those familiar with her artistic practice know that she is tireless, exacting, and self-demanding. During the decade and a half that has elapsed from the initial images in *Bone Stories* (1992–1998), her first taxonomic series, to the work in *Open Places* (2007), her most recent, she has gradually moved from wet-lab analog-image production to digital inkjet printing. During all of this time, she has maintained the highest standards and meticulous attention to the technical details of photographic image-making. Her feats include hand printing and processing mural-sized, selenium-toned fiber-based gelatin silver prints of such images as *Twelve Cats* (1992) and those in the *Cartwheel Suite* (1995).

Kornberg's series *Inchoation* (1998–2000) is a tour de force of polychrome photographic printing realized only through countless tests and trial runs of various kinds of photographic printing papers, toners, staining agents, and selective masking. (Because virtually none of the papers she used for this series are still being manufactured, these prints are particularly rare.) Looking back at this work and remembering how incredibly laborious it was, Kornberg wryly comments that today she could produce identical—or even better—versions of these images using Photoshop software and digital inkjet printing. As she observes, the advent of the digital era came at the perfect time for her. By 2000, she had pushed the possibilities of the gelatin silver print to the limit. After *Inchoation*, she abandoned her darkroom and shifted her creative focus to the computer and the potentials of digital imaging.

Kornberg invested considerable time and resources in mastering the "digital darkroom." As she had with traditional photographic processes, she also began carefully evaluating the look and feel of the different papers available for use in inkjet printers. One in particular,

Hahnemühle William Turner, stood out for its superior capacity to render delicate tonalities and luminous colors. Like working with ink wash or watercolor, inkjet printing on this cotton rag paper has allowed Kornberg to create images with a kind of illusionistic space that appears to work outward from the picture plane as if the image is lifting right off the page. As she pursued the new medium she also began photographing new subject matter: seaweed. By the time she developed the three series that make up *The Marine Algae Project* (2004–2005), Kornberg's digital-imaging skills enabled her to work at a creative level far beyond the limits of the traditional darkroom.

Kornberg made the photographs for *The Marine Algae Project* during residencies at the Whiteley Center of the University of Washington's Friday Harbor Laboratories on San Juan Island. Again, working with specimens in the laboratory's herbarium was not without its melancholy side. "Collecting in general no longer seems as appealing as it did in an earlier time, when people often indiscriminately amassed large numbers of specimens," Kornberg says. For her, such collections are a reminder of the alarming loss of species widely reported by the scientific community today—that in a handful of generations, our own species has so altered the environment as to cause a die-off of life rivaling extinctions in the age of the dinosaurs. The series *Evidence of Its Occurrence* (2005), with its specimen card bearing the ghostly stain of a plant form that is no longer present, offers a poignant echo of this loss.

Open Places (2007) plays off the imagery of faded strips of tape as similarly diminished trappings of the collecting process itself. Beyond being the final series in this exhibition, *Open Places* marks a point of transition, a shift from a content-dominated aesthetic to one more closely linked to Kornberg's initial training and sensibilities as a painter. While she is still fascinated by laboratory specimens, over time her interests have, as she puts it, "softened," and she no longer seeks the spectacle of subjects such as skulls that "speak loudly." The advent of digital-imaging technology has enabled Dianne Kornberg to re-embrace the medium of photography with an unprecedented degree of creative plasticity. With an ability to assign color or value, position or orientation to any or all of the visual elements of a photograph, Kornberg is free to explore a world of infinite visual possibilities. She is as excited as she has ever been to be making new work, and though she does not know the specifics of where she is going next, she does know that it is back to nature.

Photographer and photo historian Terry Toedtemeier is the curator of photography at the Portland Art Museum, Portland, Oregon.

Bone Stories
1992–1998

Bone Stories is a loosely knit group of images that I made over a period of several years, based on bones collected as study specimens. During a facility cleanup at Reed College, bones from courses taught in the 1930s and '40s were discovered stored in a janitor's closet. Opening the dusty and often mislabeled boxes was a highly charged experience. Like small burials, these specimens seemed imbued with meaning. My encounter with this material began my work with scientific study collections.

Black Crocs
Selenium-toned gelatin silver print

Pelican
Selenium-toned gelatin silver print

To Kate
Selenium-toned gelatin silver print

Owl Kill
Selenium-toned gelatin silver print

Twelve Cats
Selenium-toned gelatin silver print

Dog Skull
Selenium-toned gelatin silver print

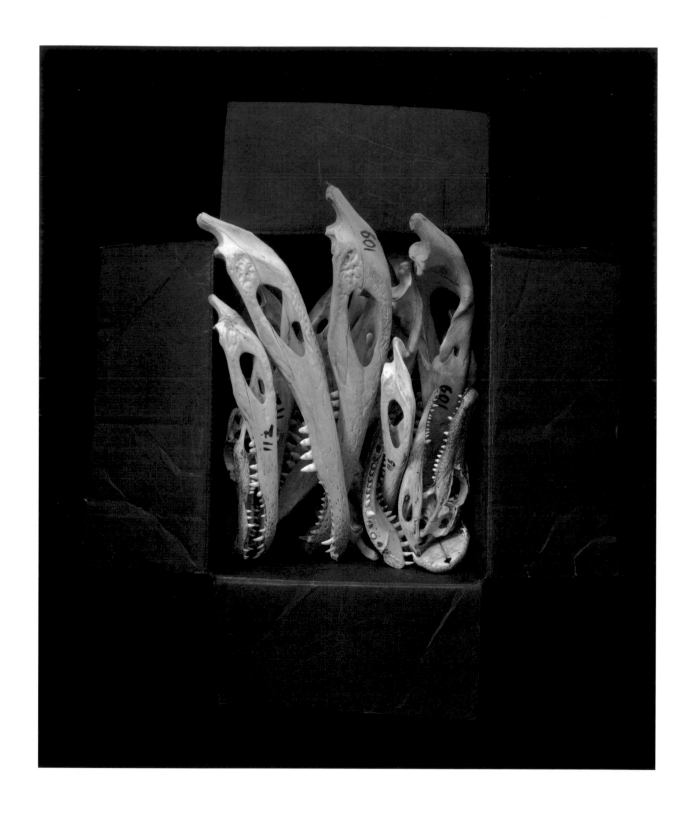

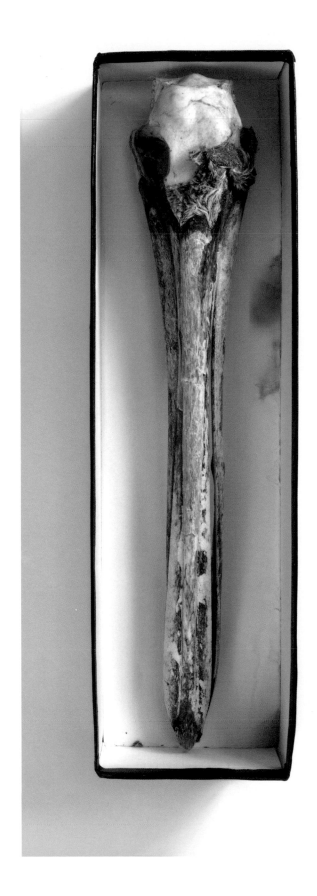

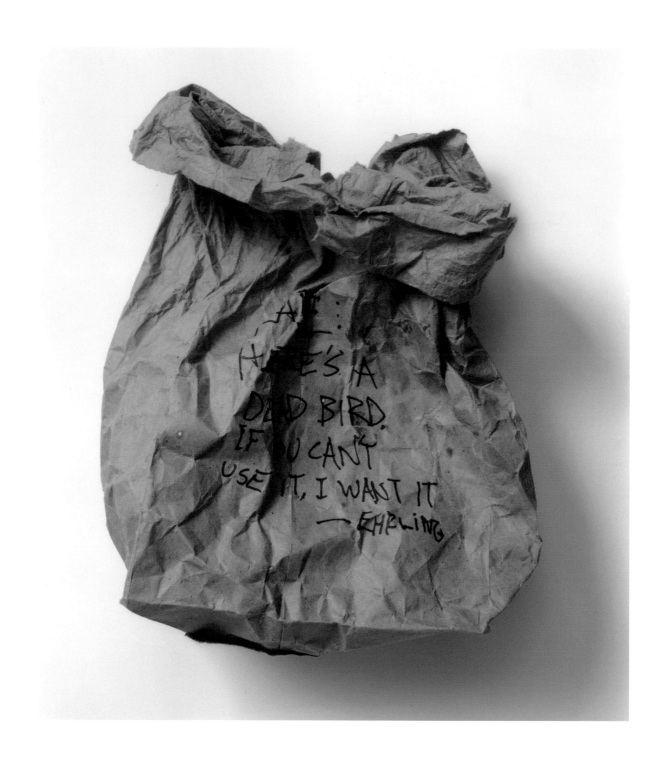

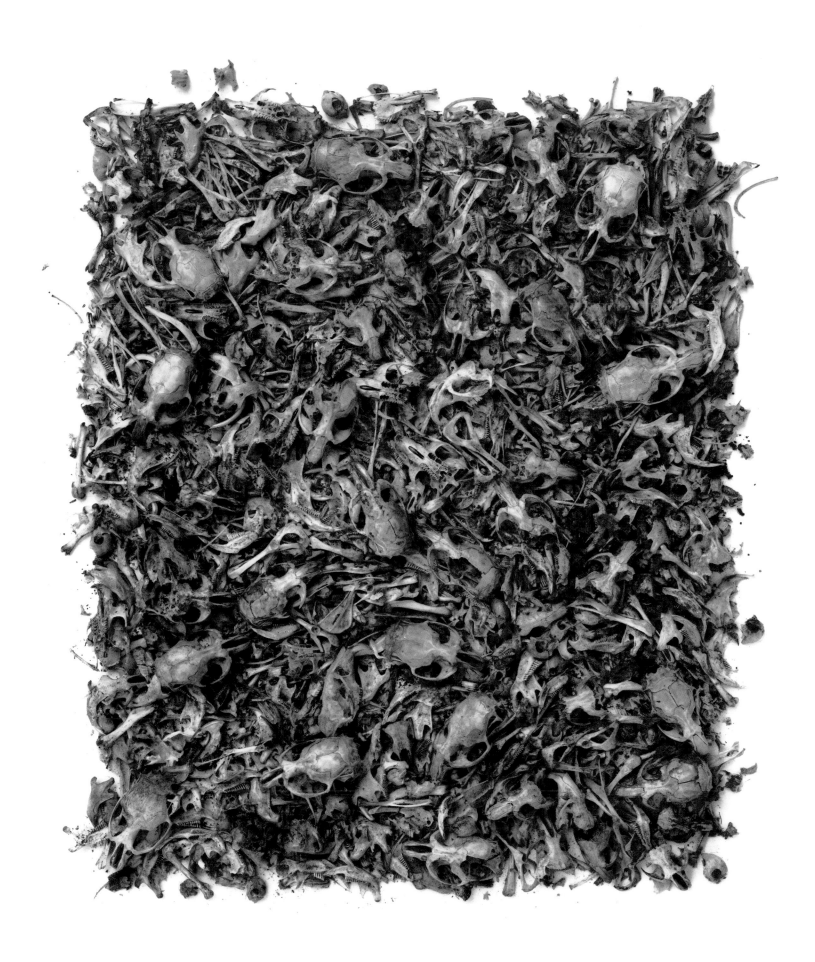

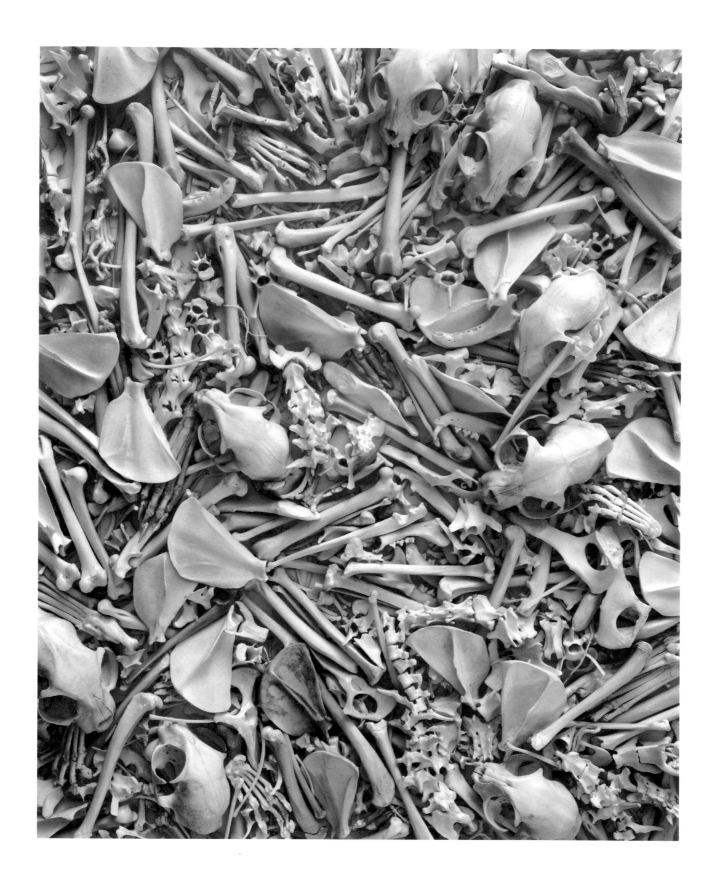

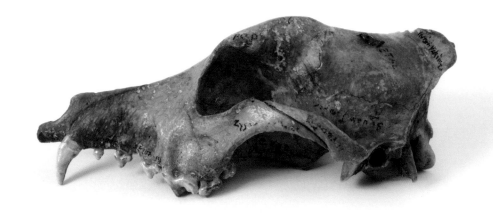

Grids
1993

I made a sequence of sixteen grids with many of the cat bones used in *Twelve Cats*. The changing arrangement of the bones from one grid to the next is reflected in the various grid structures, which are made with string, thread, and nails. The work refers to navigation (finding one's way through the unknown), archaeology (discovering order in chaos), and text. There is movement—a building up, a breaking apart, a falling down—throughout the piece.

Grid 1
Selenium-toned gelatin silver print

Grid 4
Selenium-toned gelatin silver print

Grid 14
Selenium-toned gelatin silver print

Grid 11
Selenium-toned gelatin silver print

Grid 9
Selenium-toned gelatin silver print

Grid 5
Selenium-toned gelatin silver print

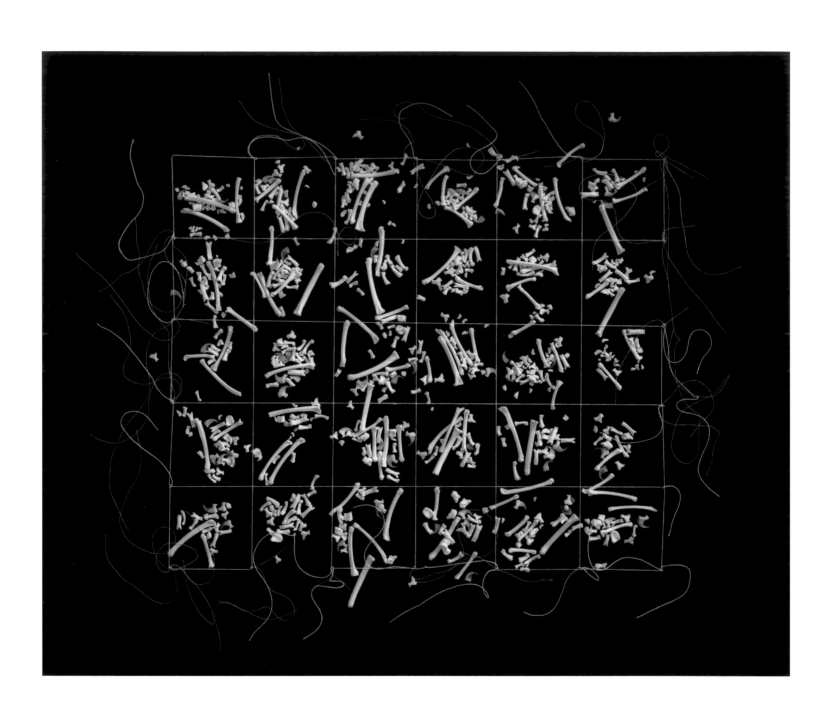

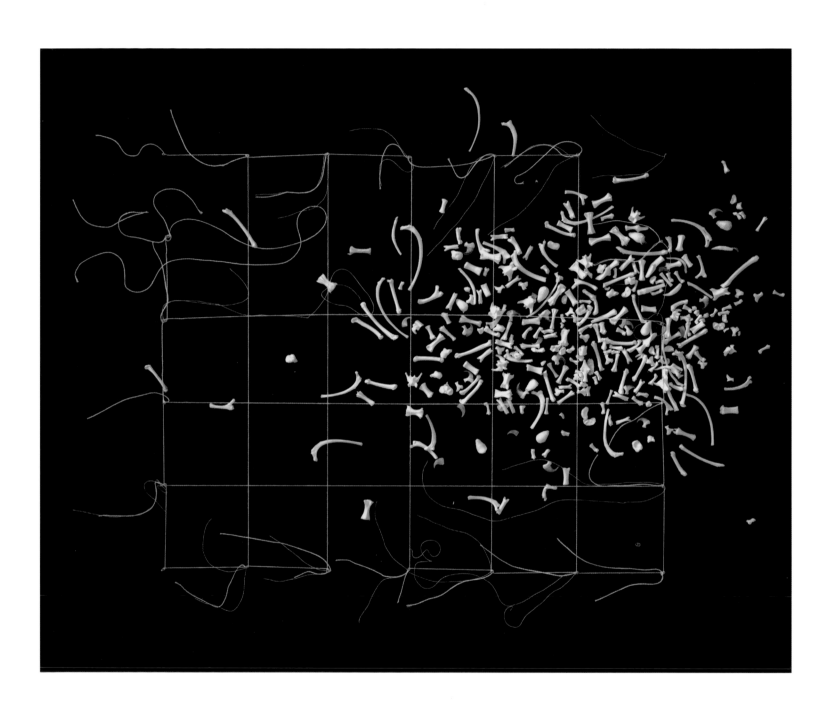

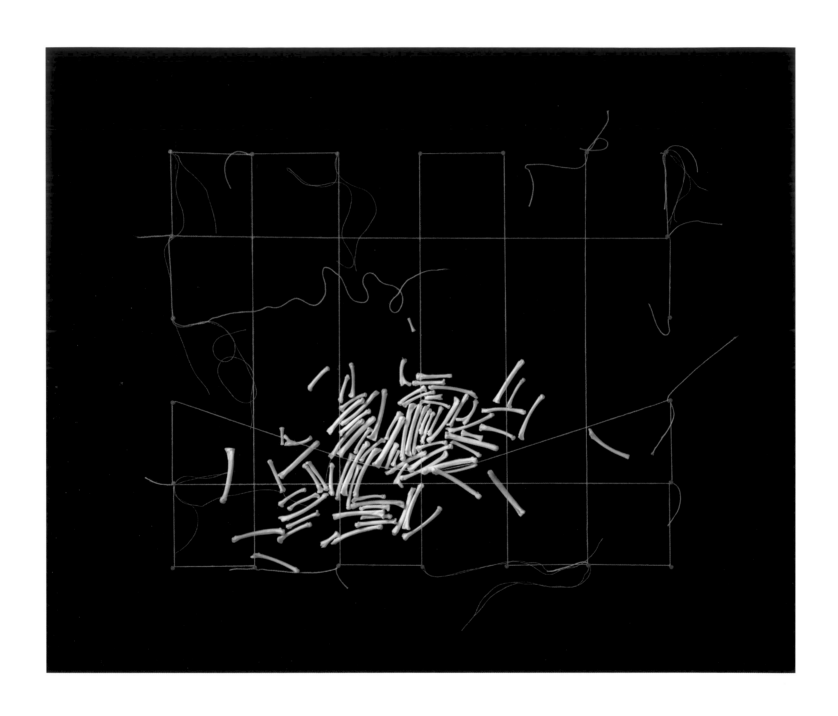

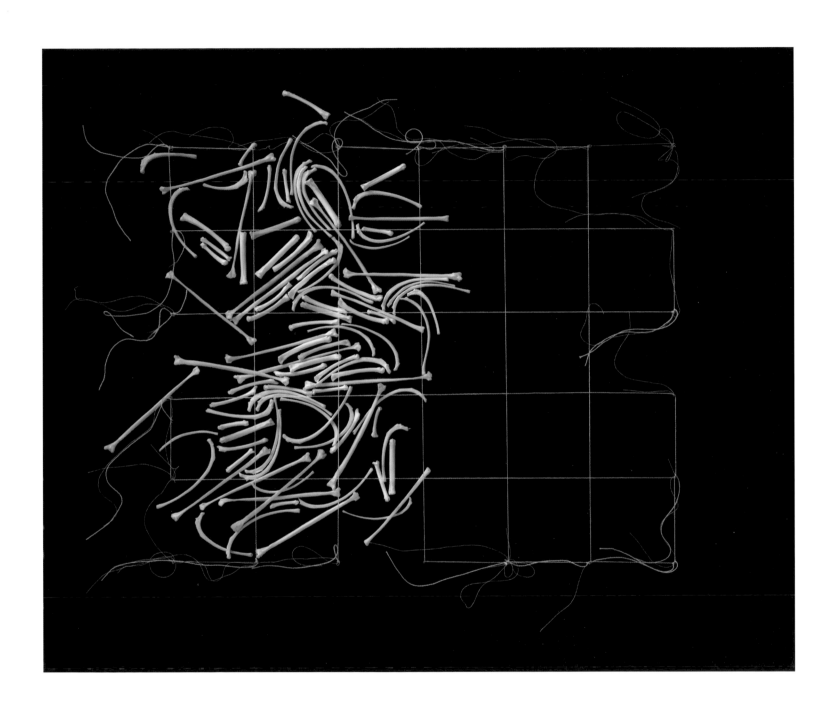

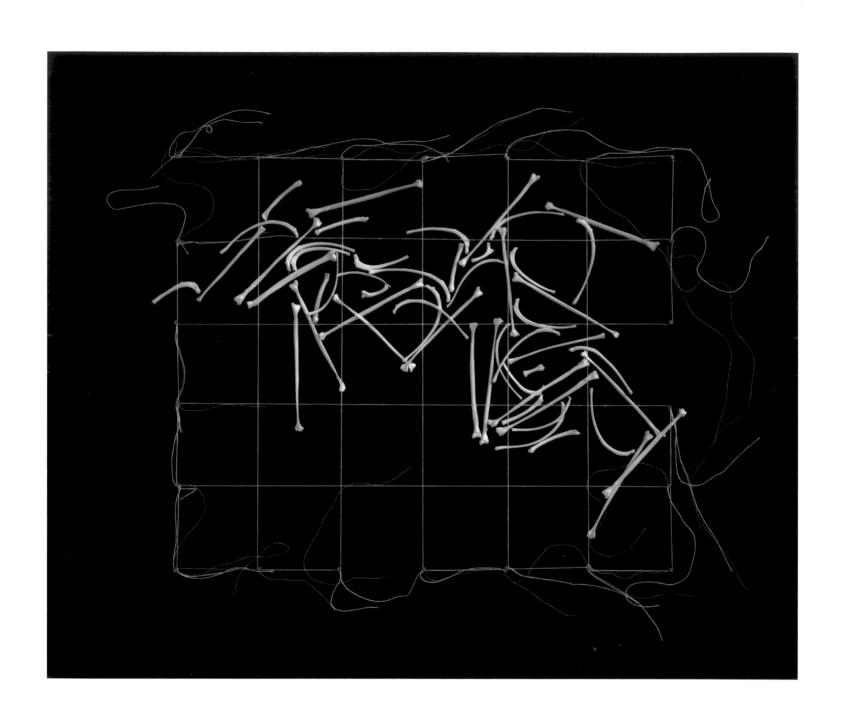

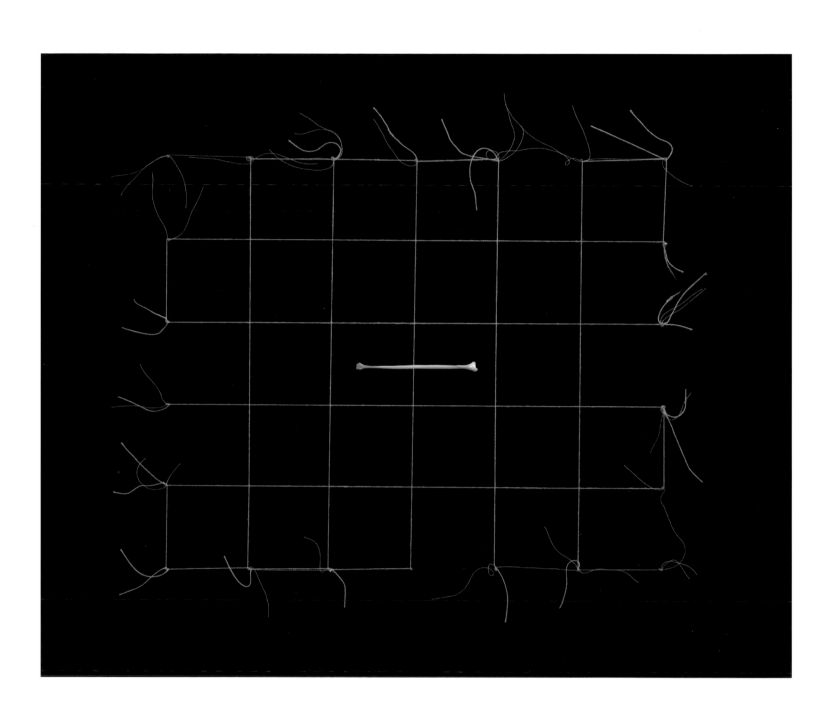

Comparative Anatomy
1993

Comparative Anatomy seeks to re-create the experience of anticipation and revelation that I had when I first opened the boxes of specimens from Reed College. With the diptych form I was able to give equal weight to the cover of the box and to its contents. The layers of text—labels, postmarks—on the candy, cigar, and scientific-supply storage containers provide historic and ironic contexts.

Aurelia
Selenium-toned gelatin silver print

Feathers of Great Blue Heron
Cibachrome diptych

Raven Skull
Selenium-toned gelatin silver diptych

Bird Skulls
Selenium-toned gelatin silver diptych

Mandibles of Cats
Selenium-toned gelatin silver diptych

Untitled
Selenium-toned gelatin silver diptych

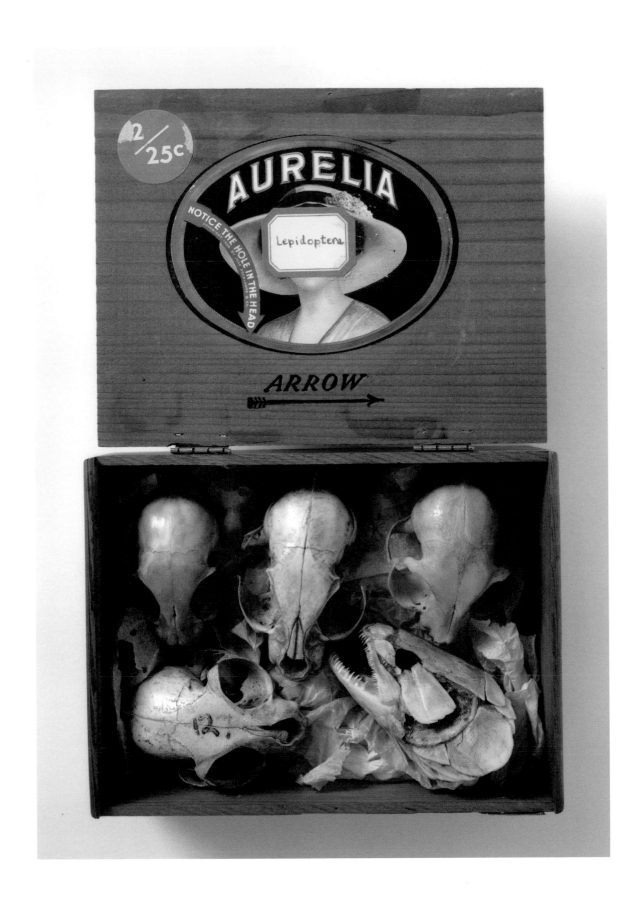

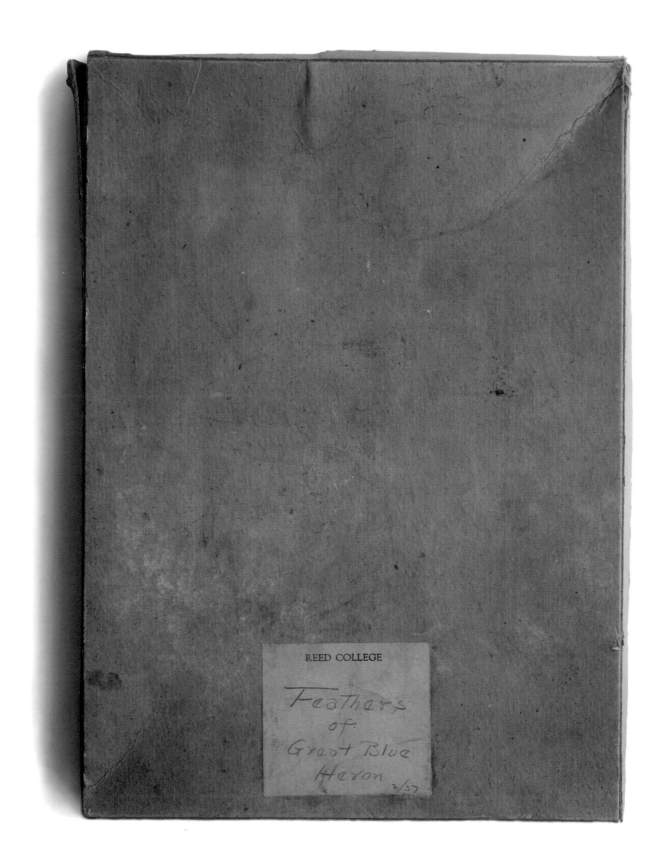

REED COLLEGE

Feathers
of
Great Blue
Heron
2/37

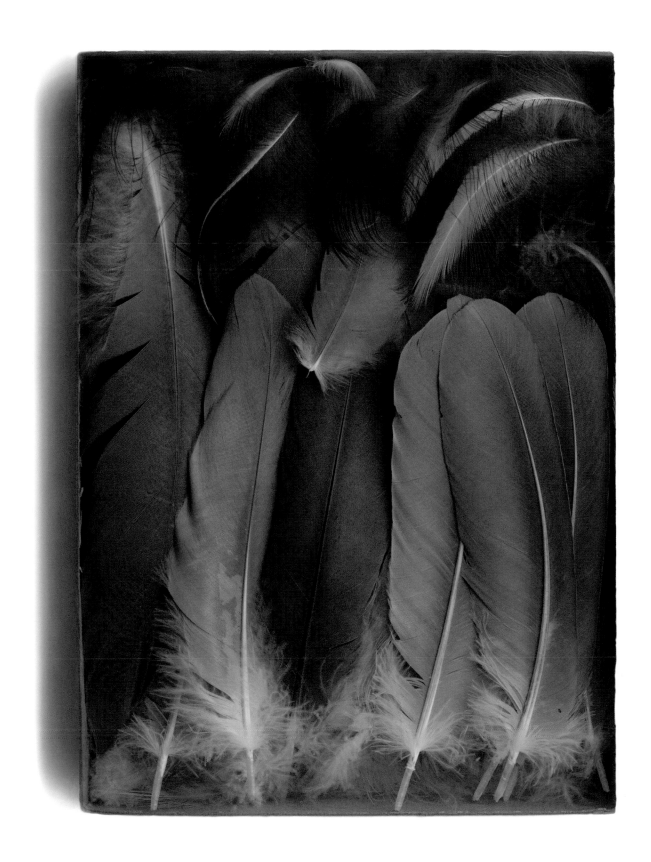

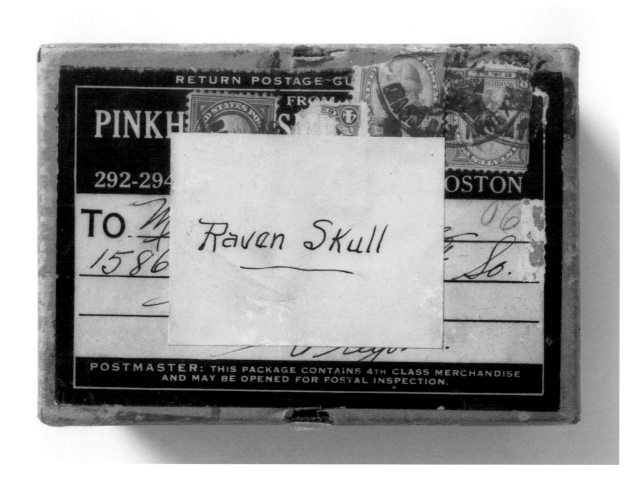

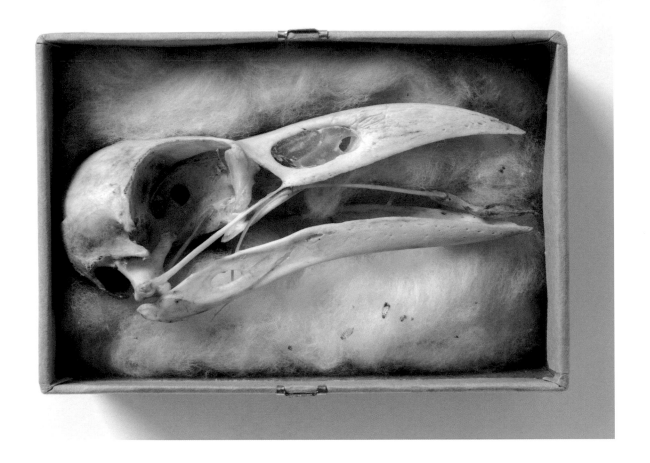

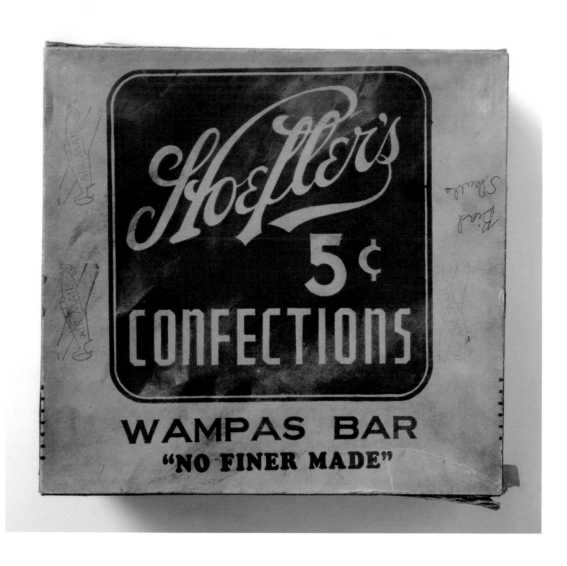

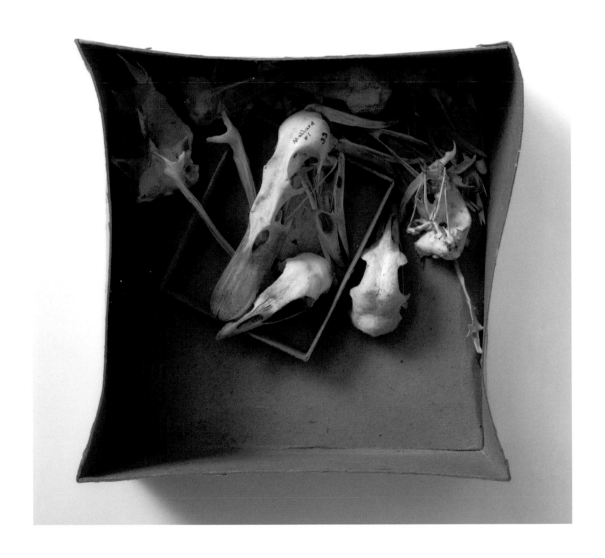

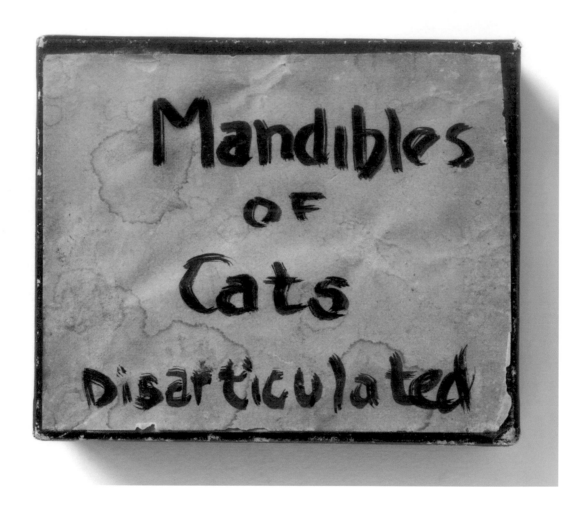

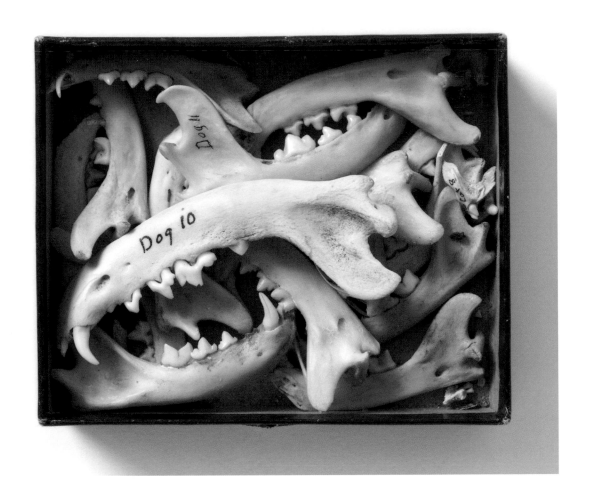

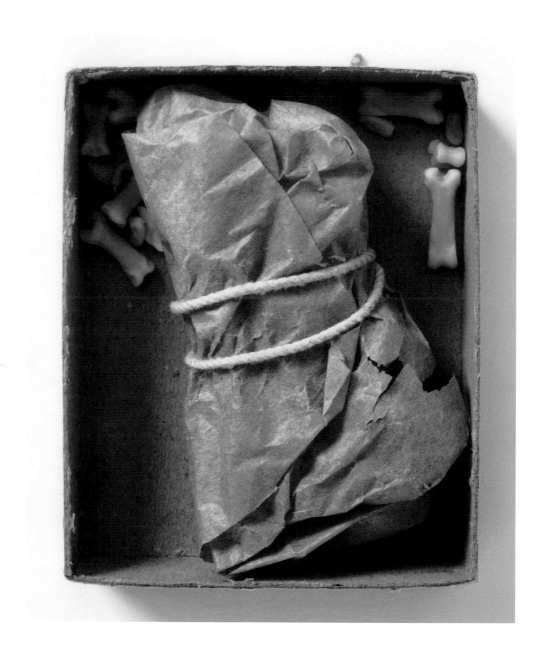

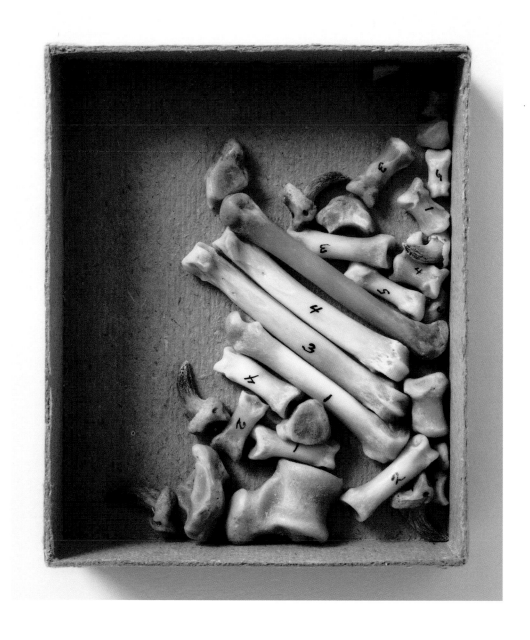

Cartwheel Suite
1995

After an interval of more than thirty years, I ran into my high-school marine biology teacher at a conference. She had developed numerous collections that were to provide me with several bodies of work. The disarticulated bones of a calf that I used in *Cartwheel Suite* came from her.

I stored the bones in a corrugated box that had contained large sheets of mat board. One evening, the light in my basement studio transformed the bones into a luminous figure, suggesting to me a "dance of death." I made alterations to the box and rearranged and rephotographed the bones until the "cartwheel" movement developed. The painted and delaminated box can be perceived in various ways (as stage curtains, coffin fabric, candy wrapper, and so on).

Together, the six images depict an acrobatic sequence in which the expressions of the figure are joyous and have a spirit of high good humor. The juxtaposition of the cartwheel and the skeletal materials suggests the Epicurean injunction *carpe diem*, "seize the day."

Cartwheel 1
Selenium-toned gelatin silver print

Cartwheel 2
Selenium-toned gelatin silver print

Cartwheel 3
Selenium-toned gelatin silver print

Cartwheel 4
Selenium-toned gelatin silver print

Cartwheel 5
Selenium-toned gelatin silver print

Cartwheel 6
Selenium-toned gelatin silver print

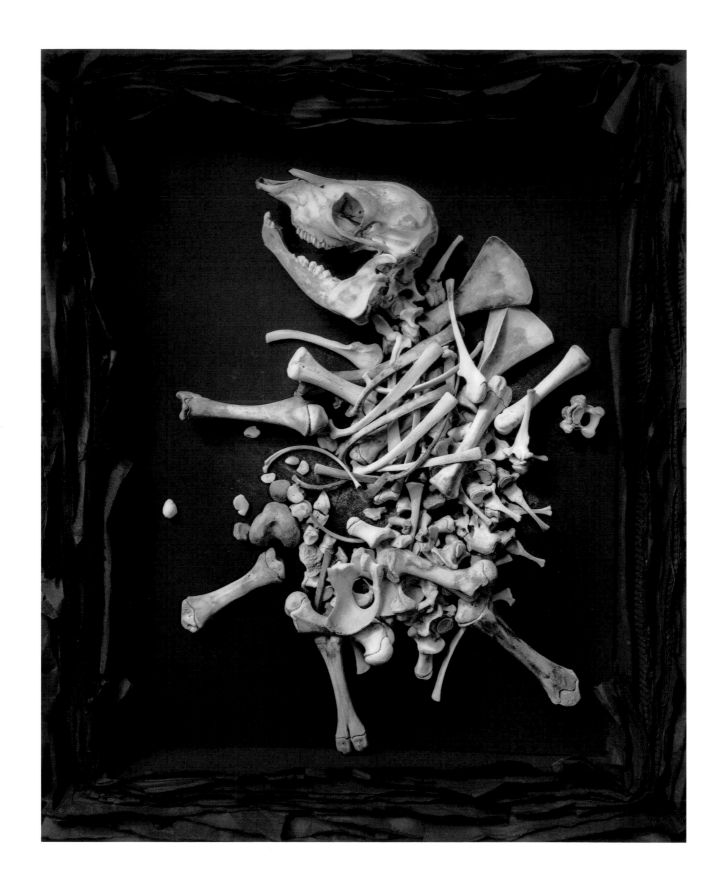

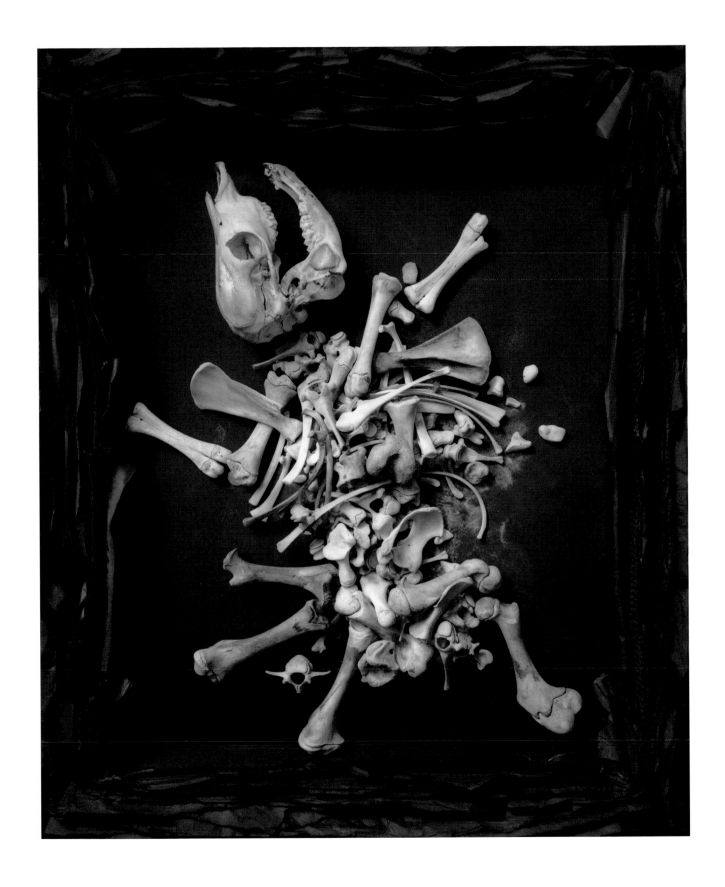

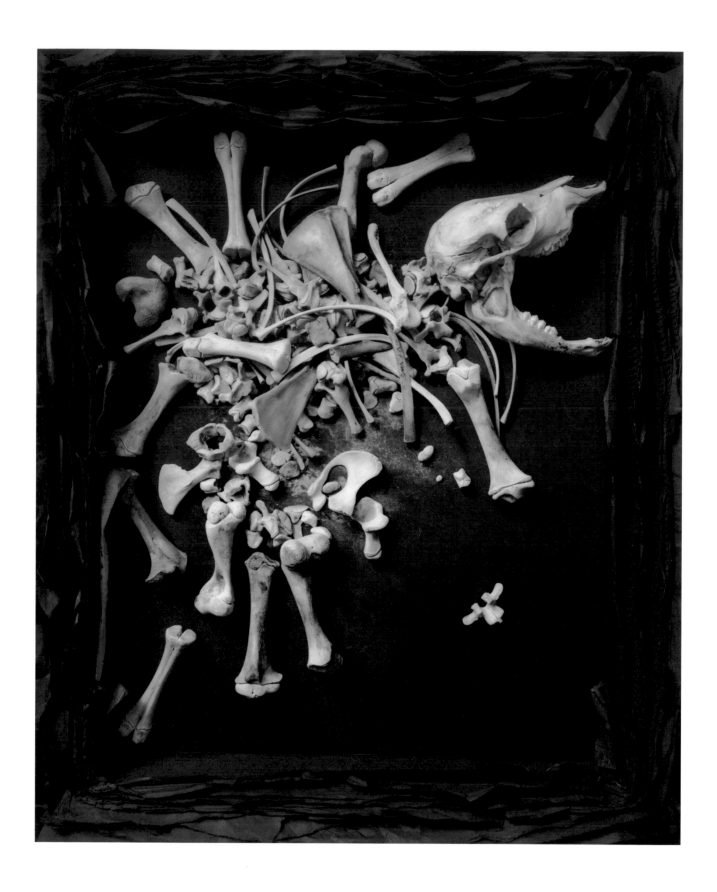

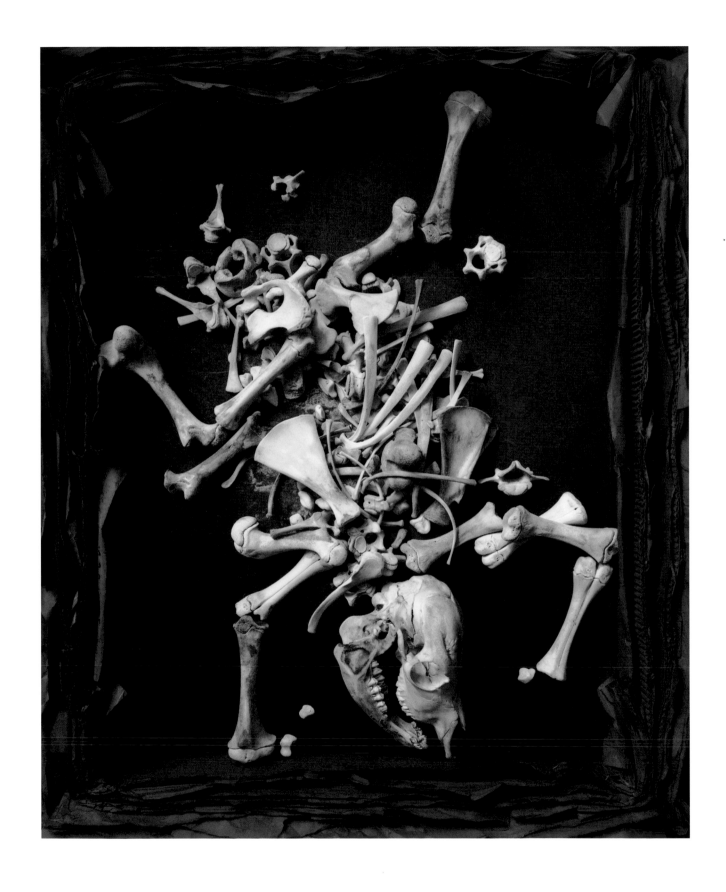

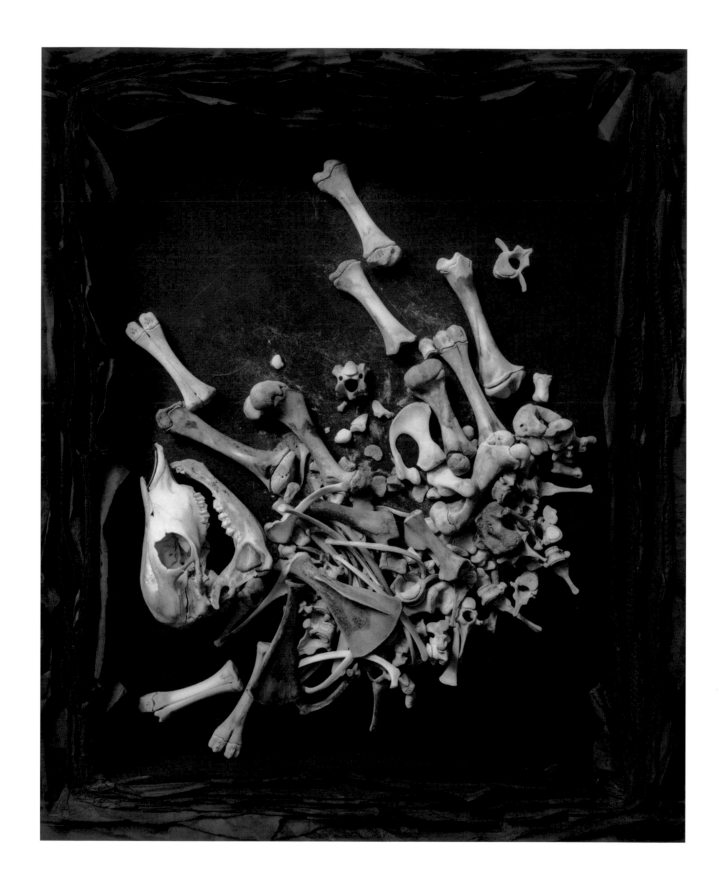

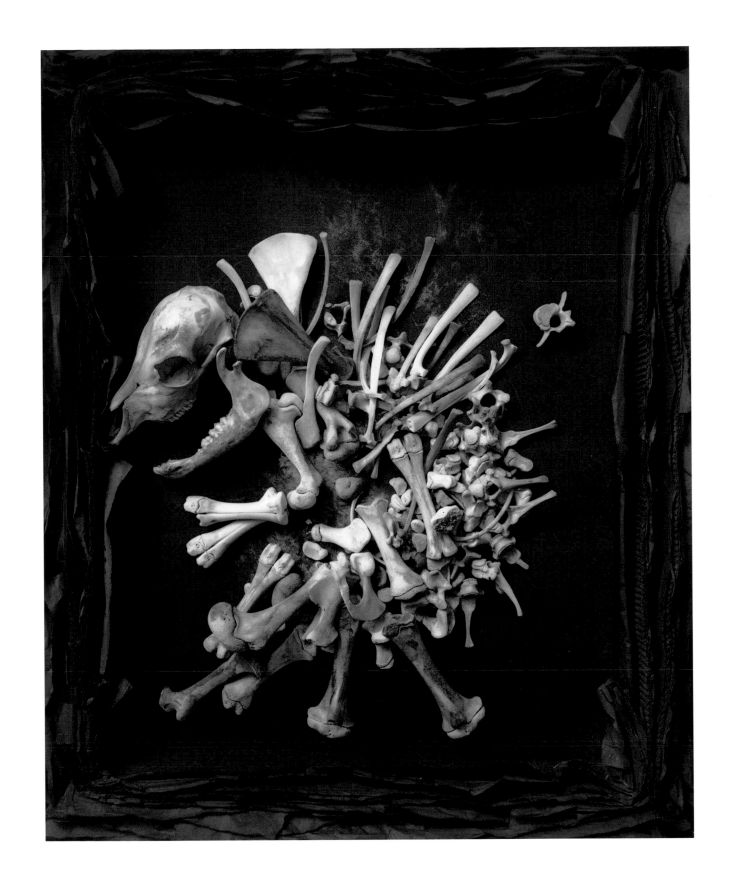

India Tigers

1995

These butterflies and moths from India were preserved in folded, triangular paper wrappings. I photographed them so that the wrappings appear to extend out from the picture plane, as might the wing of the insect. All of the images in the series rotate on an axis around a shared central point, and a delicate sense of movement is suggested as the direction of the light changes from one piece to the next.

India Tiger 1
Selenium-toned gelatin silver print

India Tiger 3
Selenium-toned gelatin silver print

India Tiger 4
Selenium-toned gelatin silver print

India Tiger 7
Selenium-toned gelatin silver print

India Tiger 10
Selenium-toned gelatin silver print

India Tiger 5
Selenium-toned gelatin silver print

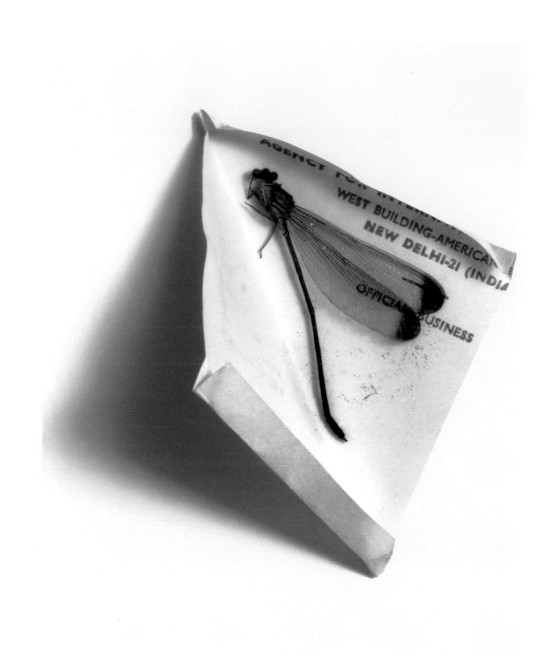

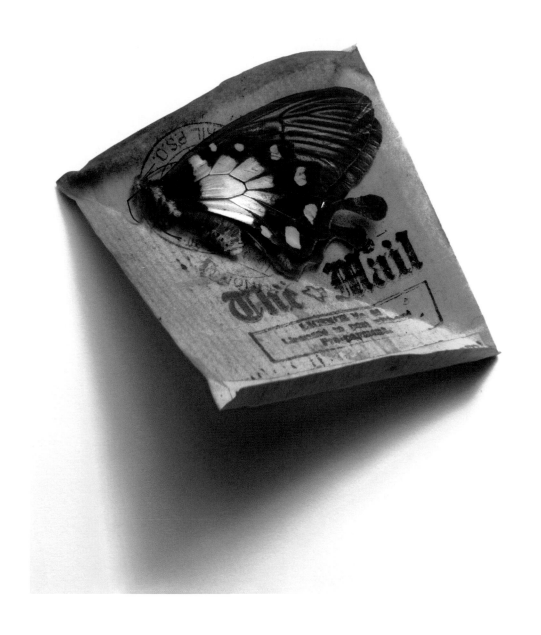

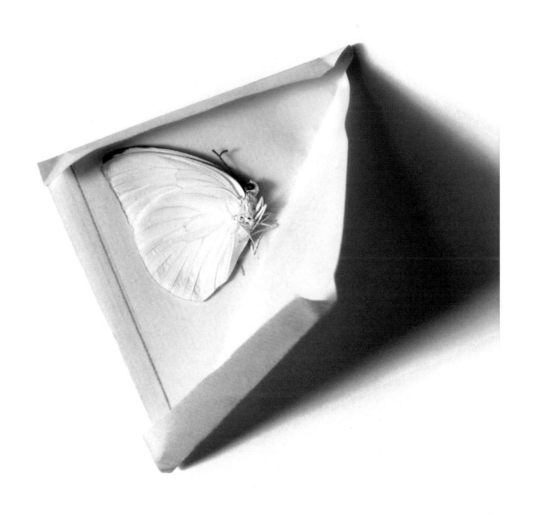

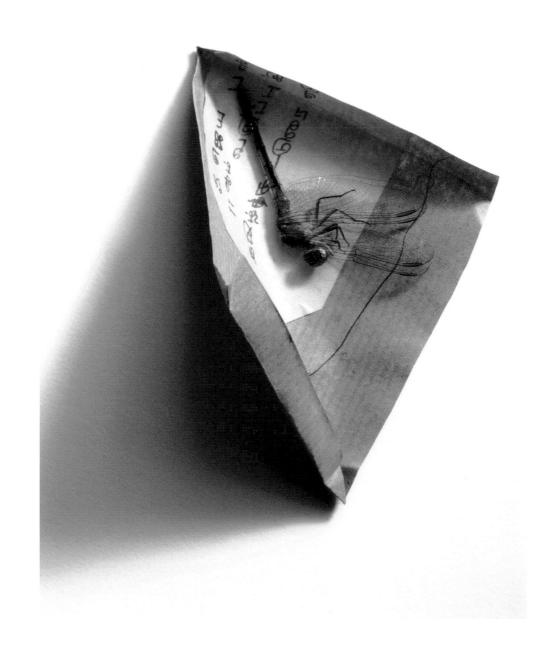

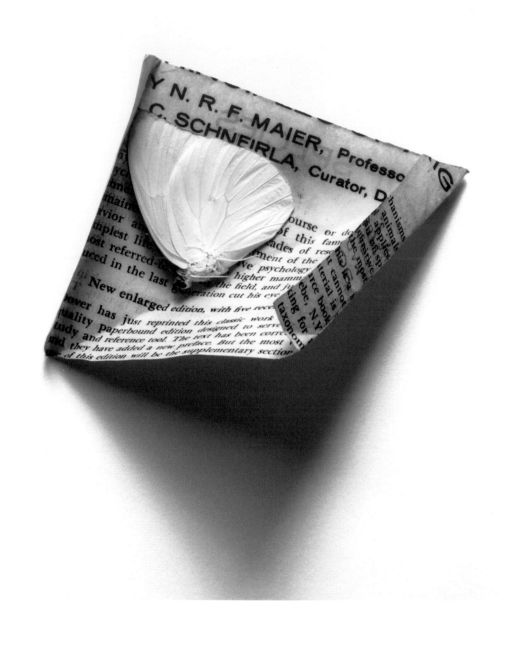

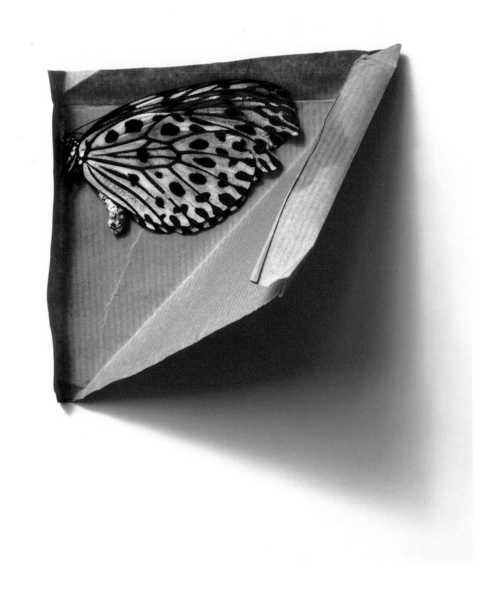

Jack-in-the-Box

1996

The diagonal lighting in this series echoes the visual impression I had when I opened the door of a weathered shed in Canada's Northwest Territories and saw a shaft of sunlight transform the bleached skull of a horse.

The title refers to the malevolent toy of that name, which provokes multiple responses: surprise, fright, laughter. Although all the images are composed using the horse skull and a piece of cloth inside a corrugated box, each suggests a unique character—a jester, a swamp creature, and so on—some more ambiguous than others.

Jack-in-the-Box 1
Selenium-toned gelatin silver print

Jack-in-the-Box 2
Selenium-toned gelatin silver print

Jack-in-the-Box 3
Selenium-toned gelatin silver print

Jack-in-the-Box 7
Selenium-toned gelatin silver print

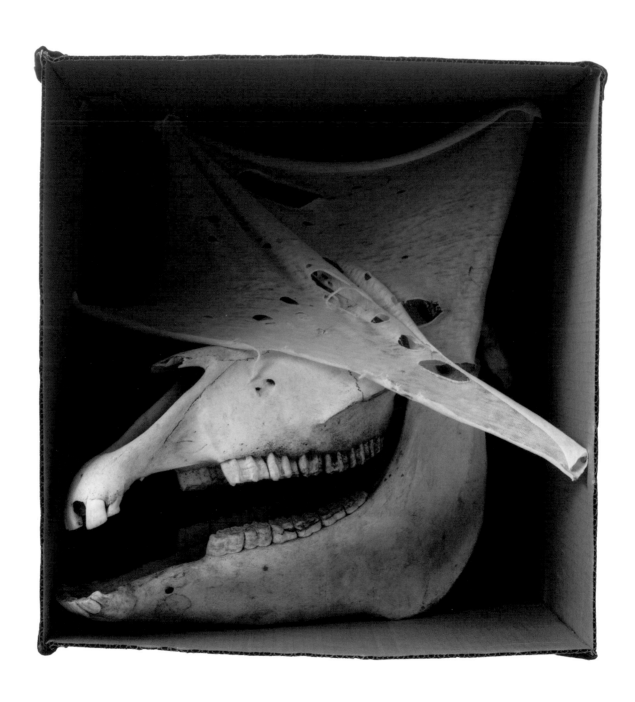

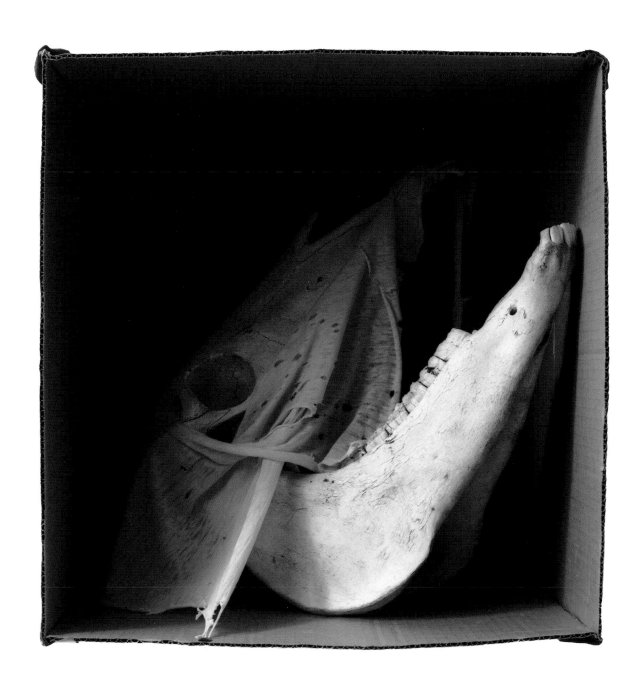

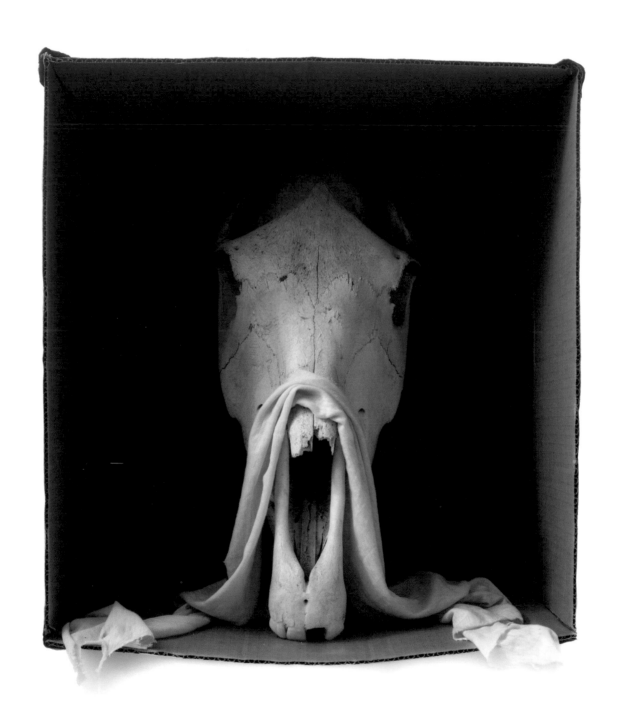

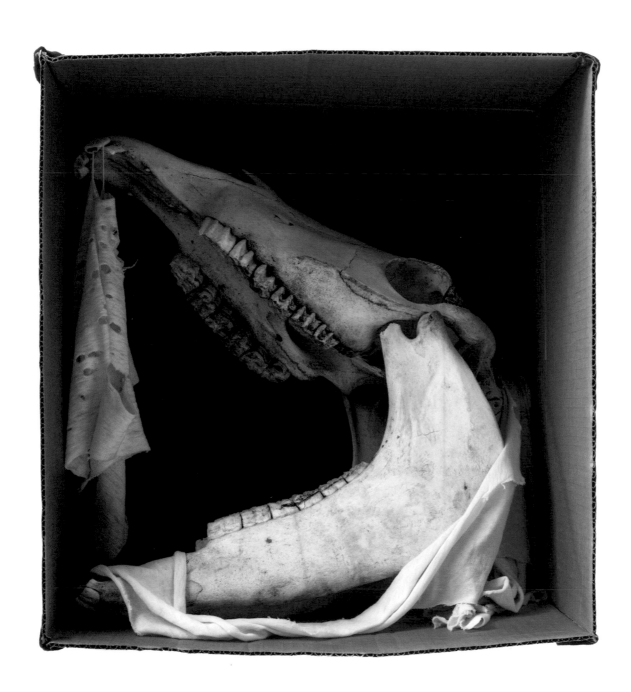

Insecta
1996-1997

The selecting and categorizing of insect specimens in collections is an effort to impose order on the diversity of nature. Some of the collections I photographed for *Insecta* were methodically arranged by scientists; others offer a random record of a collector's travels. For one of the photographs I placed a friend's treasured moth specimens in a standard collection box, which can house one insect or one thousand.

Insecta 1
Selenium-toned gelatin silver print

Insecta 3
Selenium-toned gelatin silver print

Insecta 6
Selenium-toned gelatin silver print

Insecta 7
Selenium-toned gelatin silver print

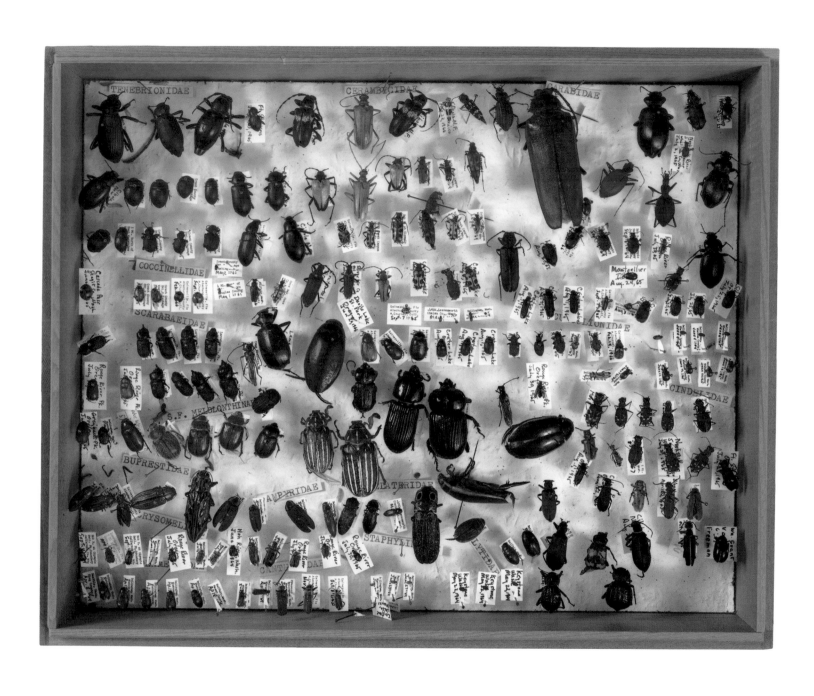

Inchoation

1998–2000

In these small portraits of animal fetal specimens from Portland State University and Lewis & Clark College, I wanted to call attention to the exquisite way in which form evolves, and to the evolutionary history and life force that we share with other living beings. The colors are achieved by selective masking in conjunction with various combinations of toners and stains.

Dasypus novemcinctus
Gold-toned gelatin silver print

Felis silvestris
Coffee-stained, selenium-toned gelatin silver print

Lepidochelys olivacea
Gold-toned gelatin silver print

Equus caballus
Sepia- and selenium-toned gelatin silver print

Corvus corax
Coffee-stained, selenium-toned gelatin silver print

Raja binoculata
Gold-toned gelatin silver print

Didelphis virginiana 1
Sepia- and selenium-toned gelatin silver print

Sus scrofa
Gold-toned gelatin silver print

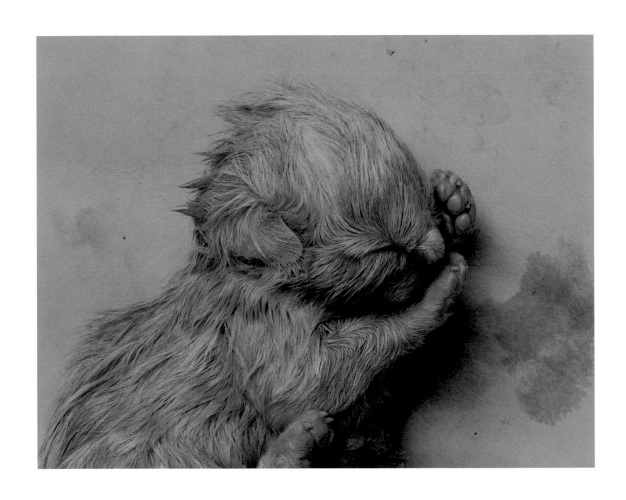

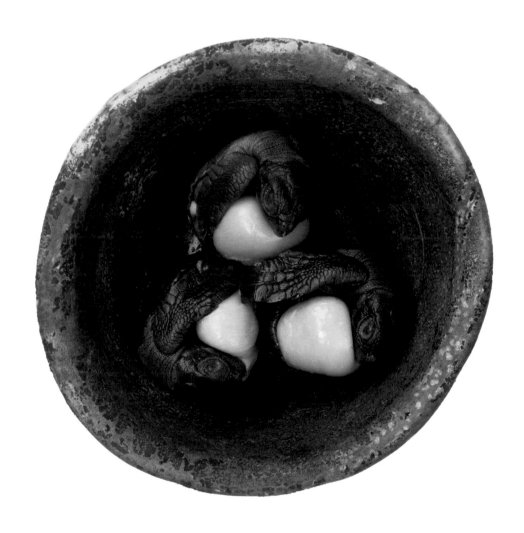

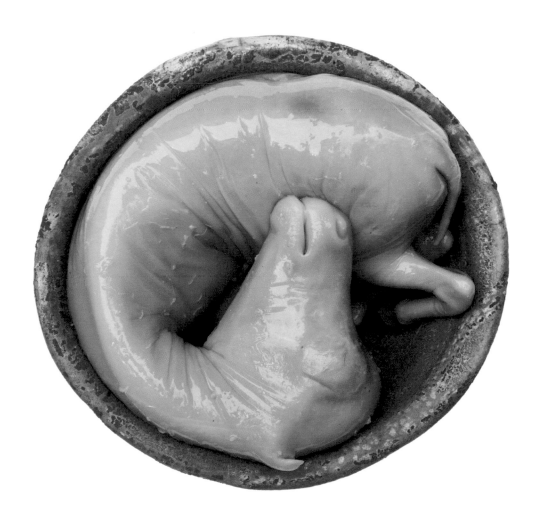

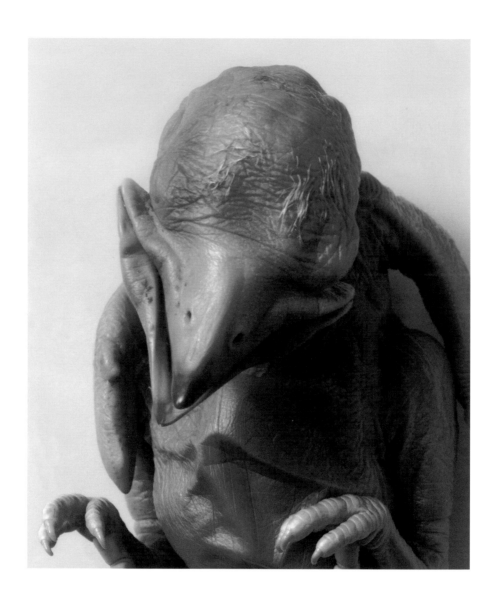

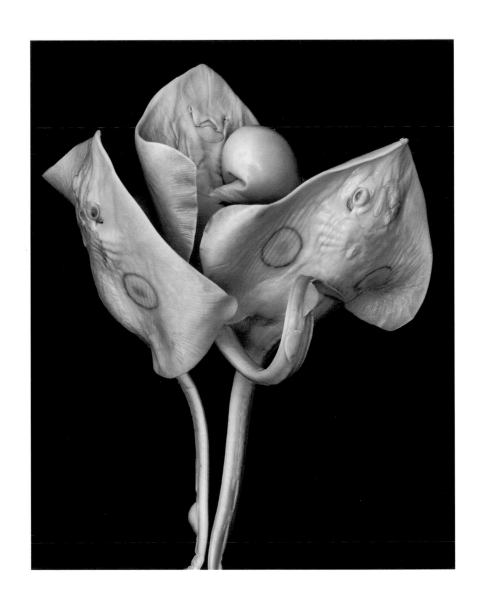

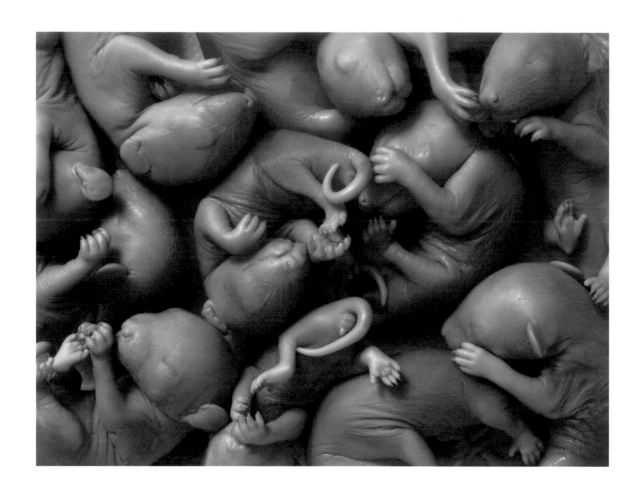

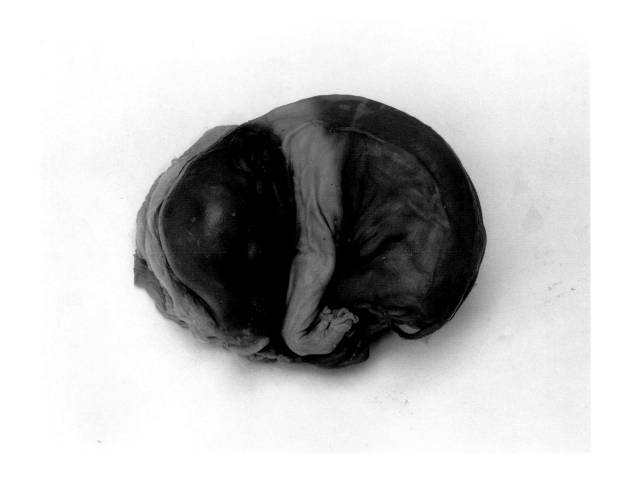

The Marine Algae Project

In the spring of 2003 I was invited to spend a month at the Whiteley Center residence for scholars and artists at the University of Washington's Friday Harbor Laboratories on San Juan Island. In particular, I was there to photograph in the marine algae herbarium. I had started taking pictures of seaweeds from the Lewis & Clark College herbarium in 2000, and inkjet printing made it possible for me to represent this material in the way that I envisioned. Unlike the silver gelatin surface of a conventional photograph, the physicality of the ink on paper closely mimics the thinly pressed algae specimens, and the photographic prints take on attributes of graphic media such as watercolor or pastel.

I find these preserved specimens extraordinarily affecting. While they give evidence of species and serve as material for scientific research, they carry metaphoric and aesthetic content as well. A visual elegance transcends the erosions of time and use. Primarily, it is this that I am after.

The Marine Algae Project comprises three groups of work: *Celebration Quartet*, *Cors Mortale*, and *Evidence of Its Occurrence*.

Celebration Quartet
2004

The shapes of the seaweeds in *Celebration Quartet* suggest chalices raised in toast.

Celebration 1
Pigment inkjet print

Celebration 2
Pigment inkjet print

Celebration 3
Pigment inkjet print

Celebration 4
Pigment inkjet print

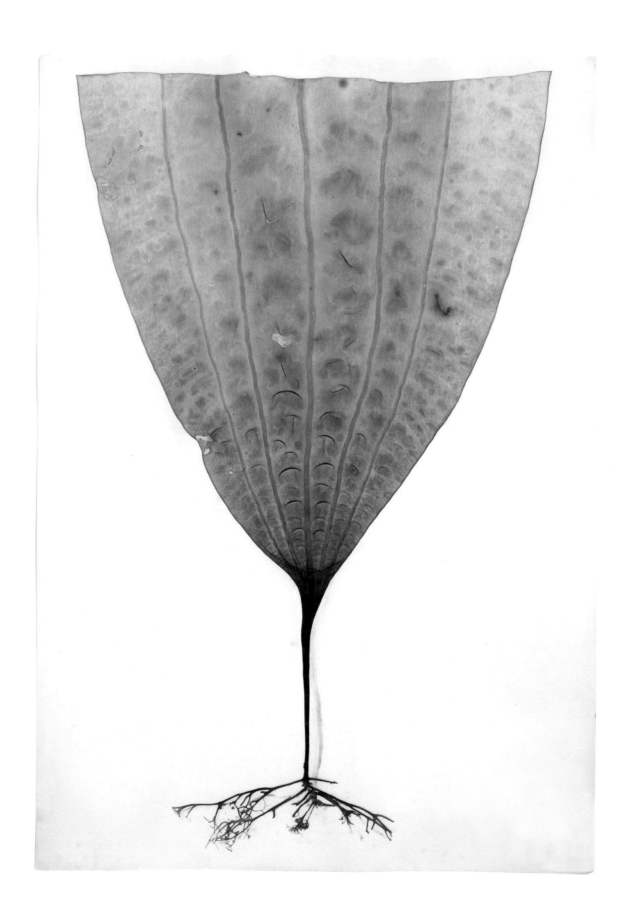

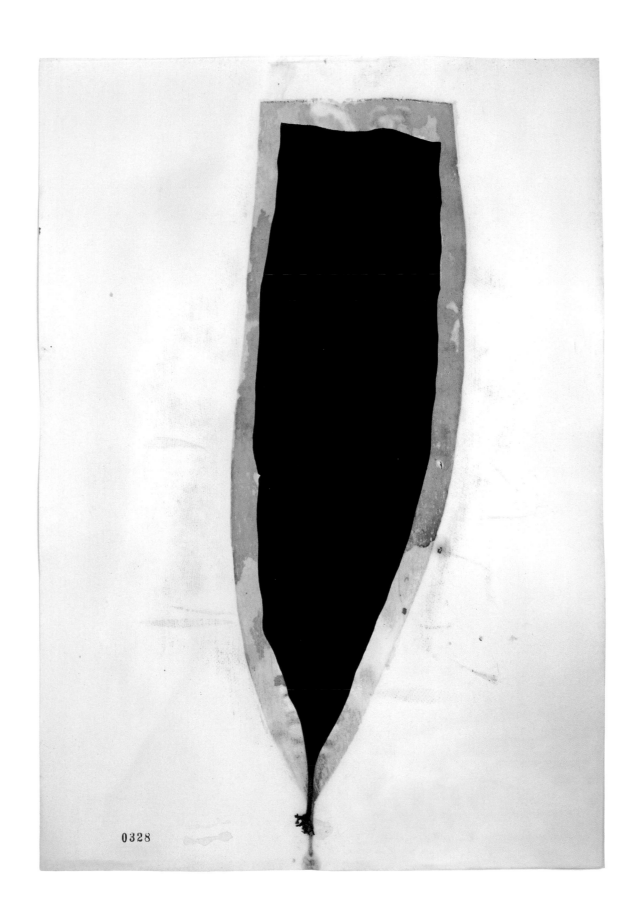

0328

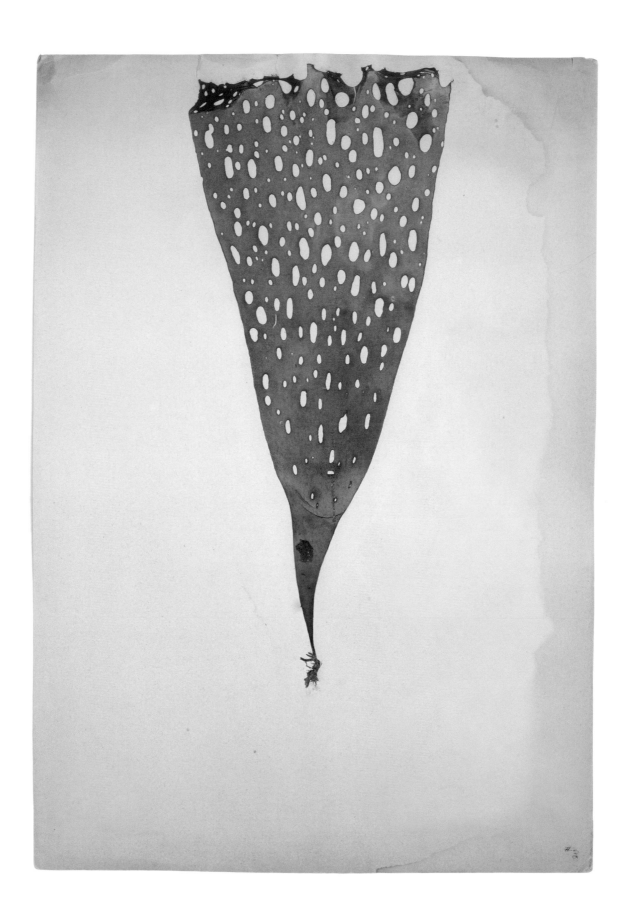

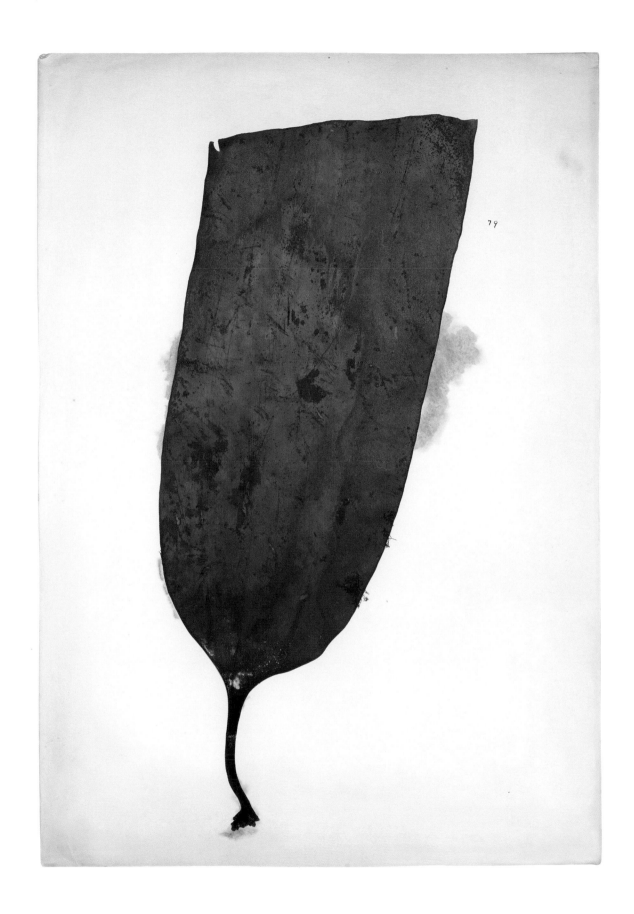

79

Cors Mortale
2004

Cors Mortale, Latin for human (mortal) heart, is a play on descriptive taxonomic determinations of genus and species. As I looked through hundreds of marine algae specimens, remarkable and suggestive forms began to recur. In this series the seaweeds represent hearts—as muscles, as icons, as metaphors. I created my own Latin nomenclature for these images, based on taxonomic naming conventions.

C. vigoratum
Pigment inkjet print

C. eruptionis
Pigment inkjet print

C. minimum
Pigment inkjet print

C. pulsum
Pigment inkjet print

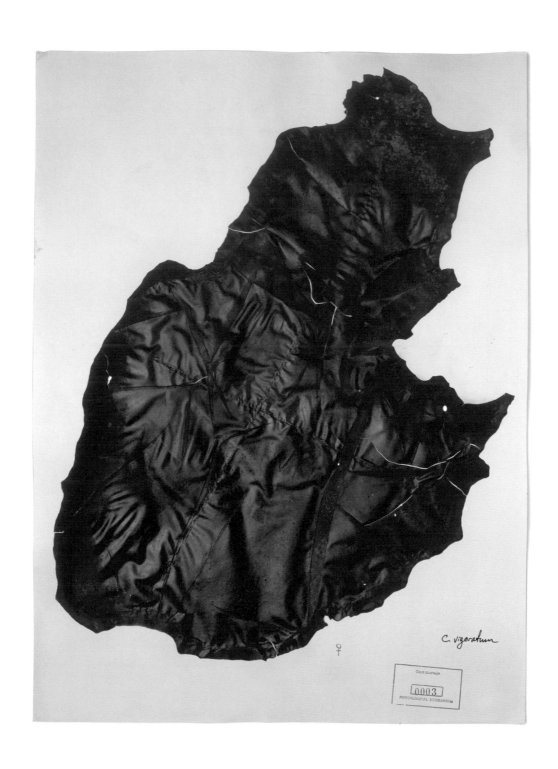

♀

C. vigoratum

Chos morale

0003

PHYCOLOGICAL ECHBARIUM

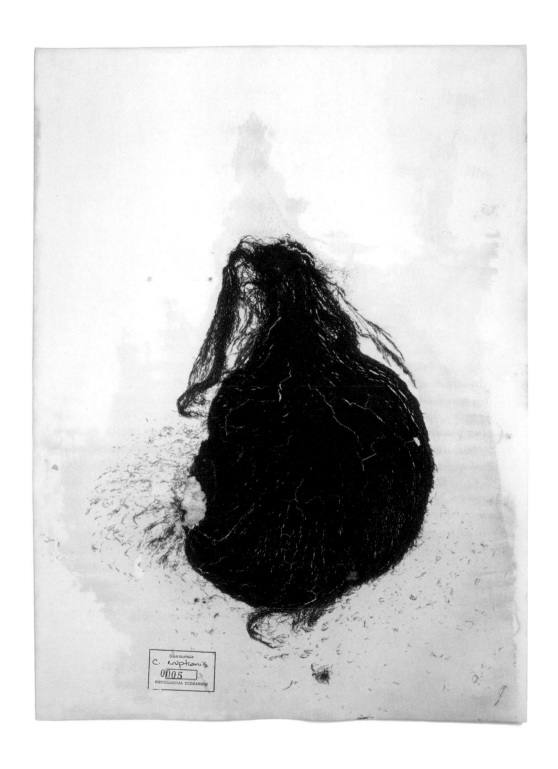

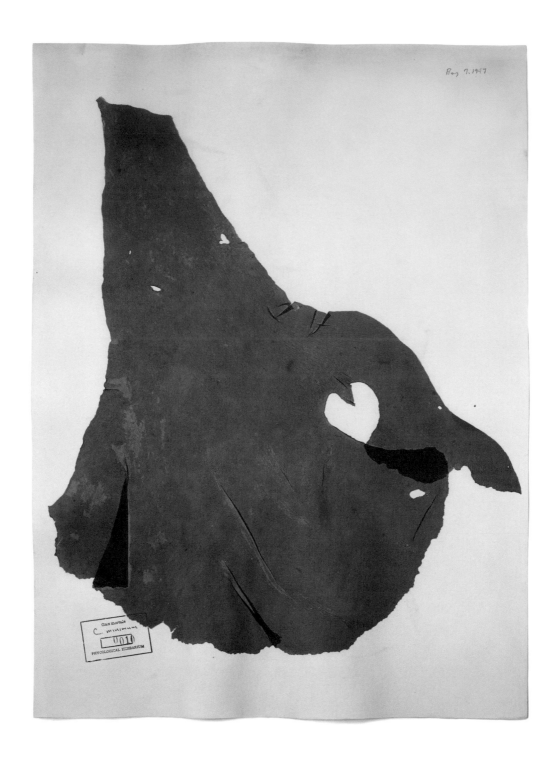

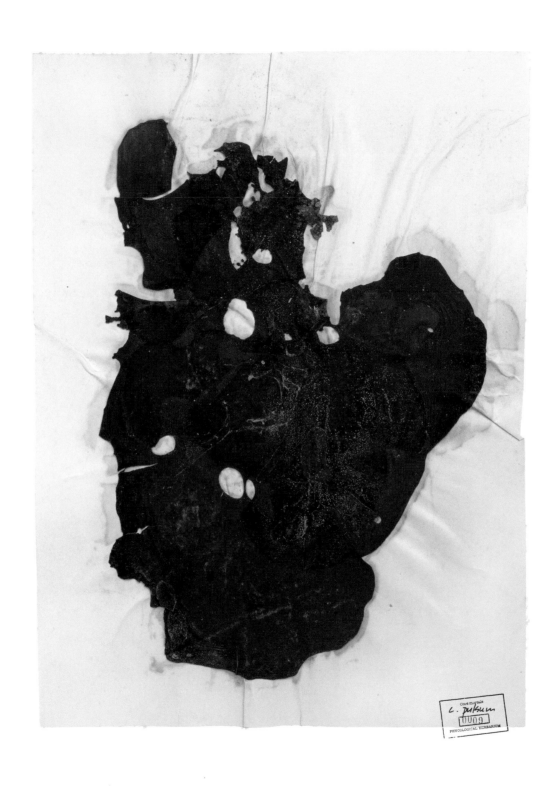

Evidence of Its Occurrence
2004-2005

This work takes its name from text I found on a specimen card that carried just a stain of what had once been preserved. The piece *Evidence*, which bears part of this text, serves as a sort of frontispiece, referring to the value of collecting, preserving, and identifying as a basis for scientific knowledge and understanding. The text takes on elegiac resonance in this age of habitat depletion.

Evidence
Pigment inkjet print

A. marginata
Pigment inkjet print

Porphyra
Pigment inkjet print

S. gaudichaudii
Pigment inkjet print

N. leutkeana 1
Pigment ink jet print

N. leutkeana 2
Pigment inkjet print

L. bullata
Pigment inkjet print

R. pertusa
Pigment inkjet print

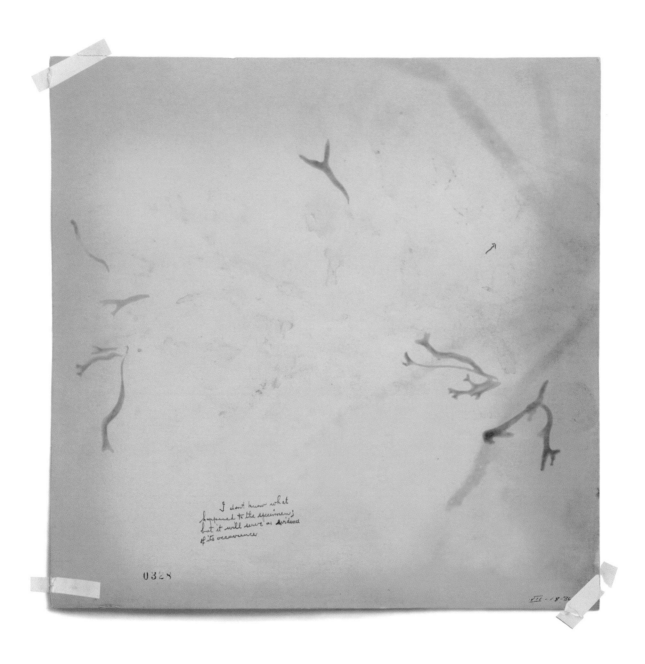

I don't know what happened to the specimens but it will serve as evidence of its occurrence

0328

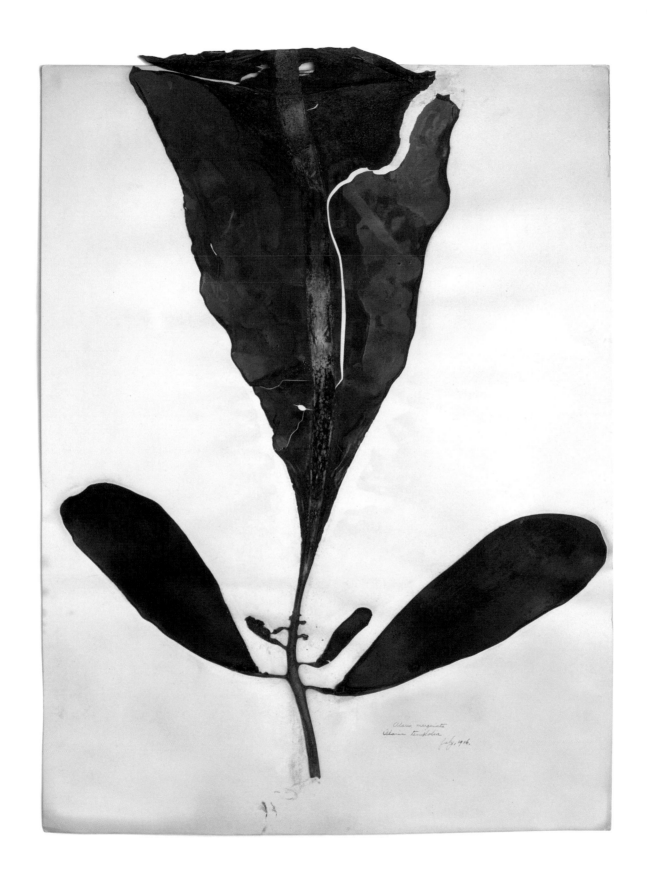

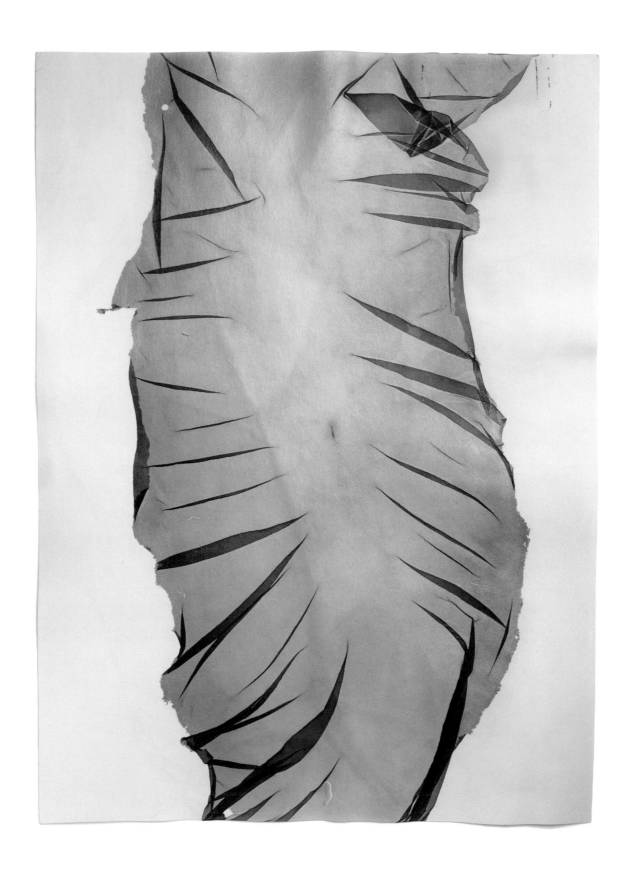

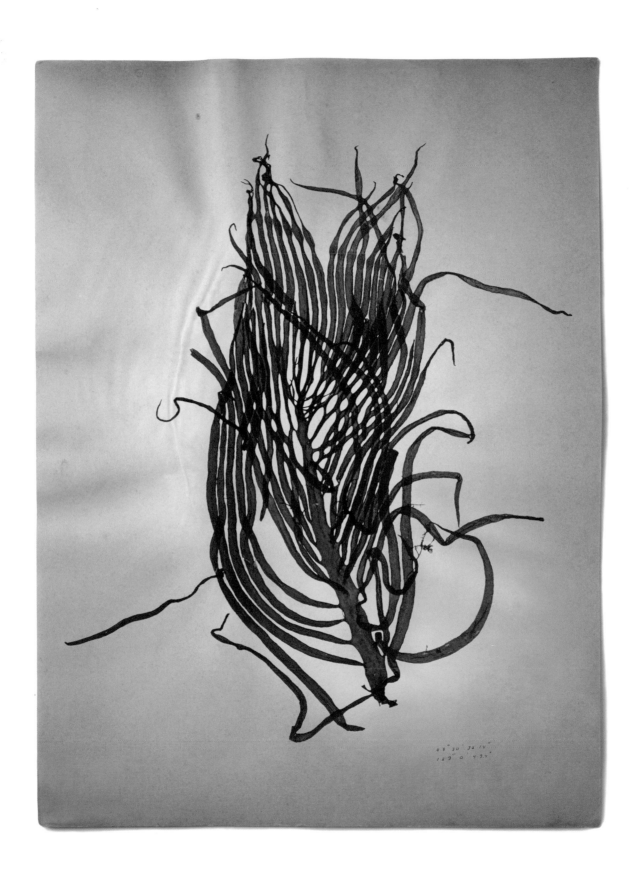

91

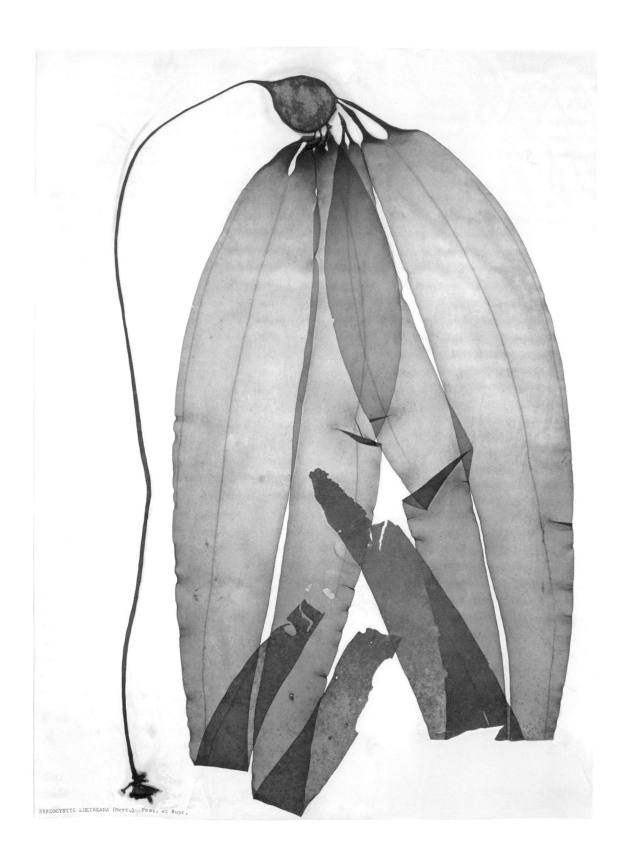

NEREOCYSTIS LUETKEANA (Mert.) Post. et Rupr.

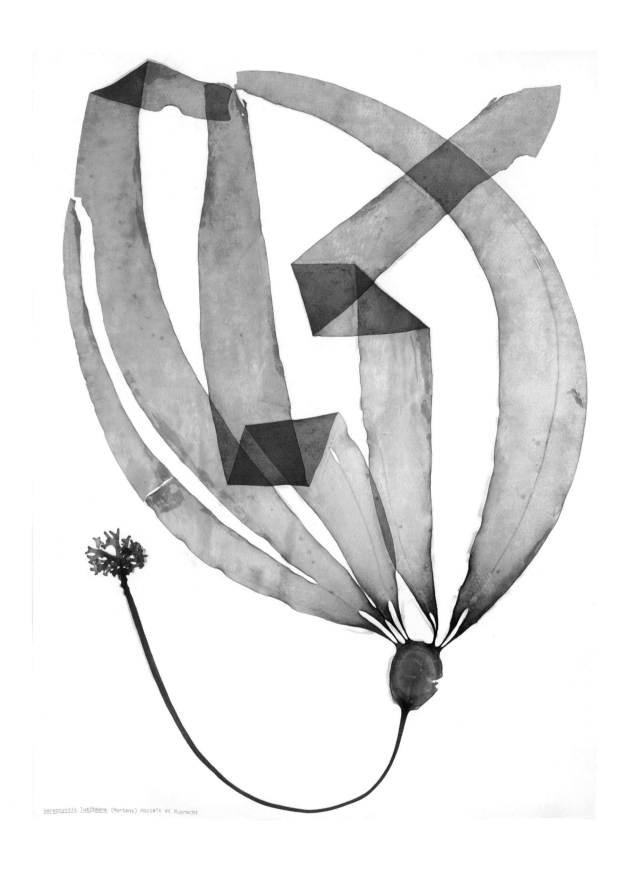

Nereocystis luetkeana (Mertens) Postels et Ruprecht

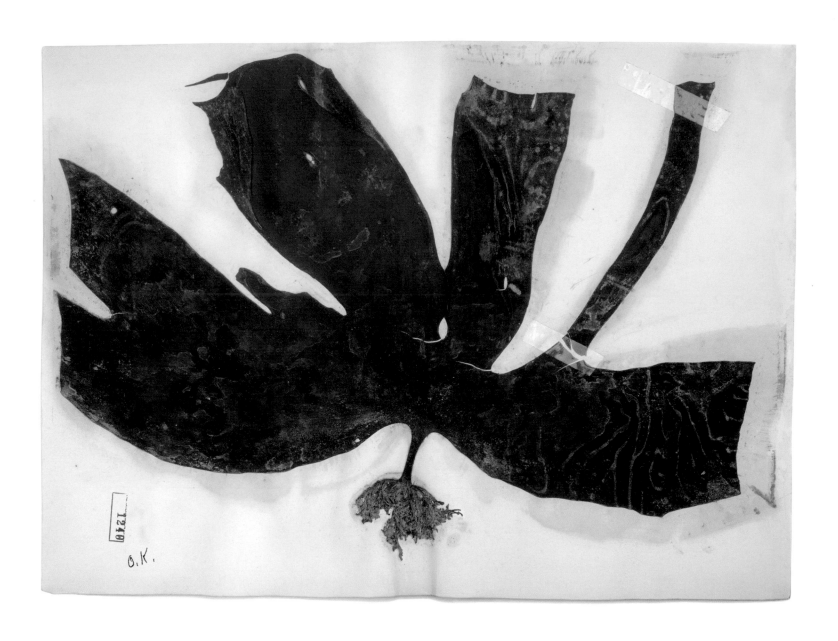

O.K.

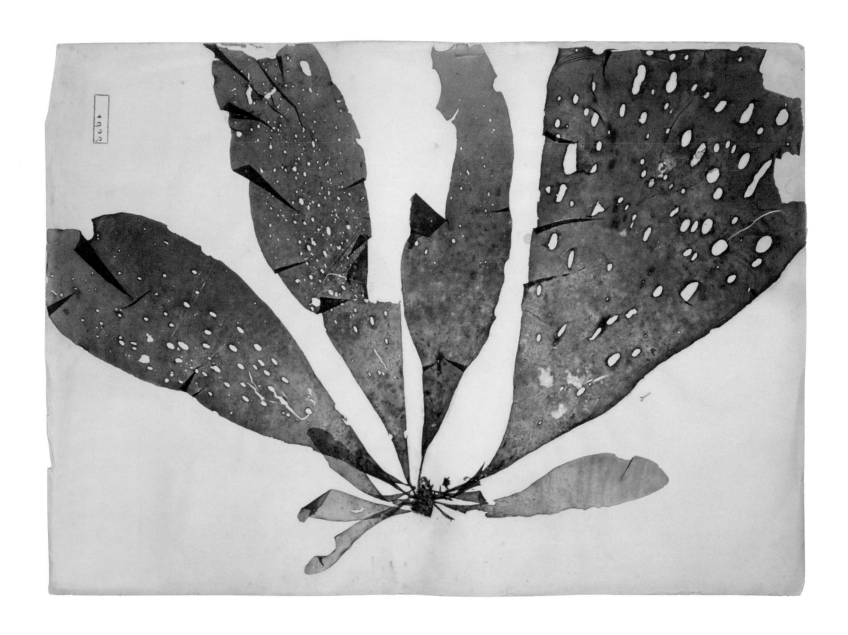

Open Places
2007

During a second artist residency at the Whiteley Center in 2004, I took a few days off from my work with marine algae to look through a small herbarium of higher plants. I came across a collection made by Julia Fritz and T. C. Frye in 1908 and photographed a selection of the specimens. I was especially taken by the bits of "tape"—usually strips cut from labels—that bound the pressed plants to the paper. With no clear idea about how I wanted to proceed with these transparencies, I put them aside while completing *The Marine Algae Project*.

When I returned to these photographs in 2006, I found that adding more strips of label and tape increased the spatial dimension of the pieces and provided an abstract counterpoint to the figurative reproductions of the specimens.

Pathfinder
Pigment inkjet print

Alpine Butterweed
Pigment inkjet print

Buttercup
Pigment inkjet print

Cotton Grass
Pigment inkjet print

Smartweed
Pigment ink jet print

Water Buttercup
Pigment inkjet print

Horsetail
Pigment inkjet print

Marsh Salt Grass
Pigment inkjet print

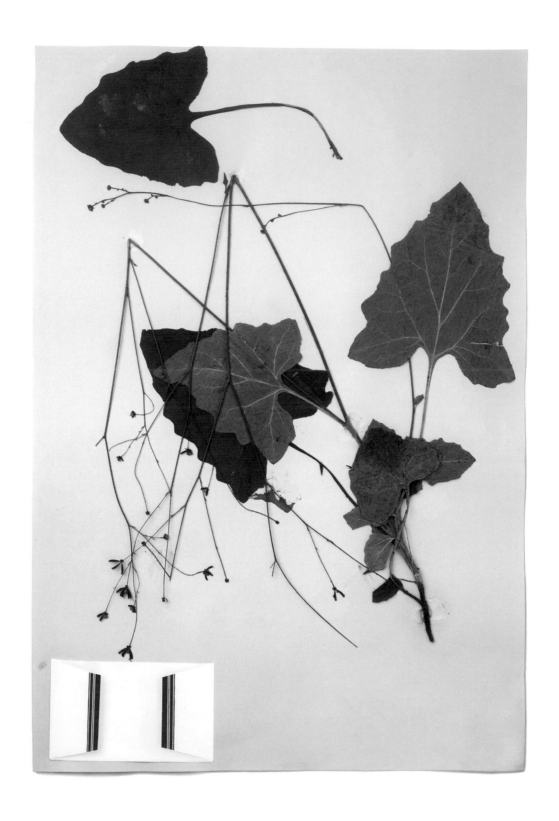

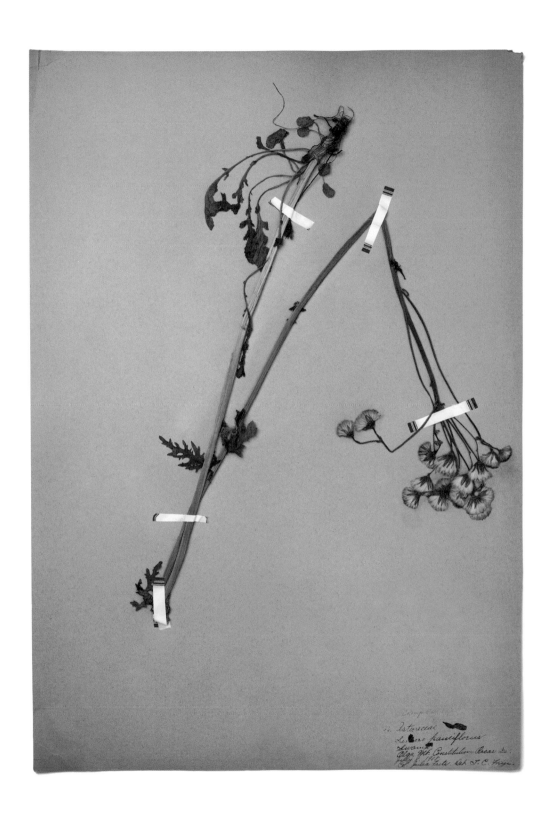

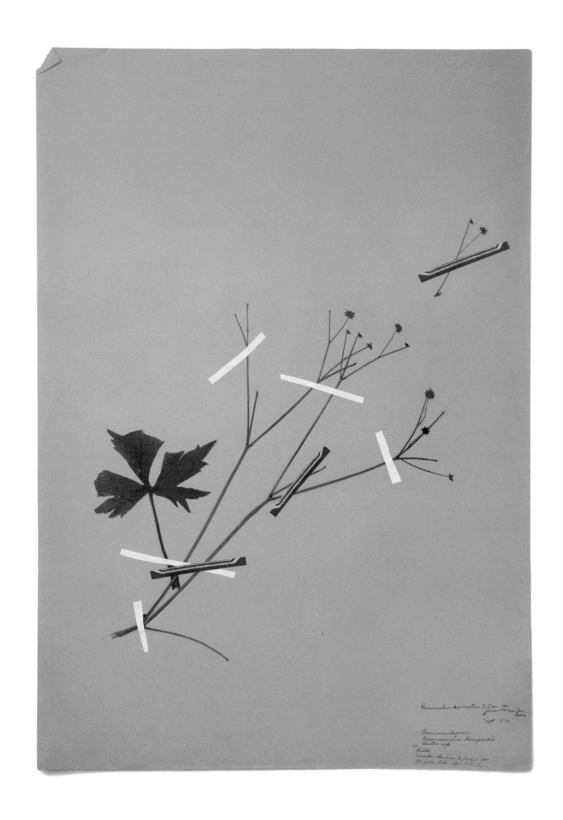

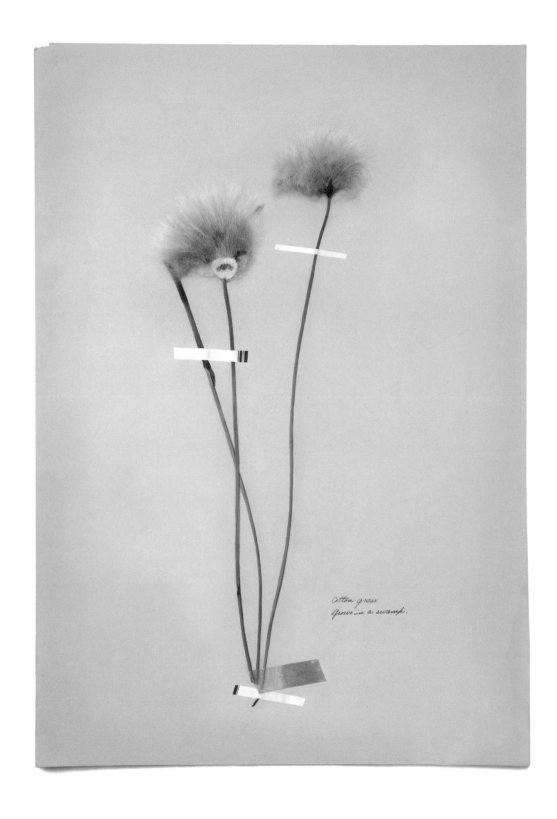

Cotton grass
grows in a swamp.

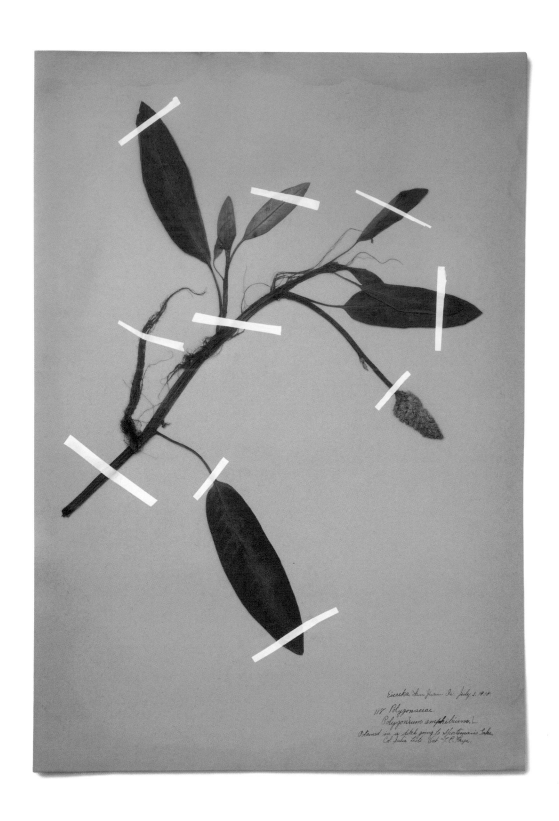

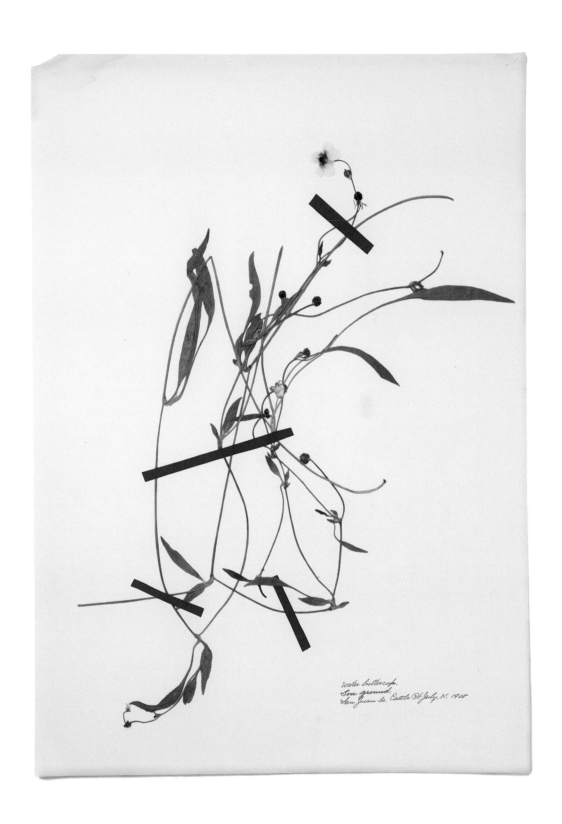

water buttercup.
Sou ground.
San Juan Is. Cattle Pt July. N. 1905

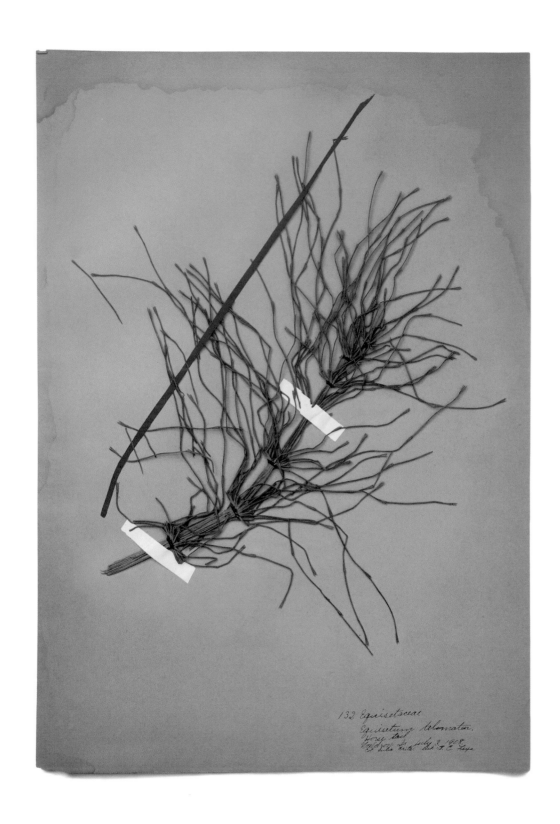

132 Equisetaceae
Equisetum telomateia.
Horse tail
Upper Lake Dist. July 3, 1908
Upper Lake Dist. Del. J. E. Faye

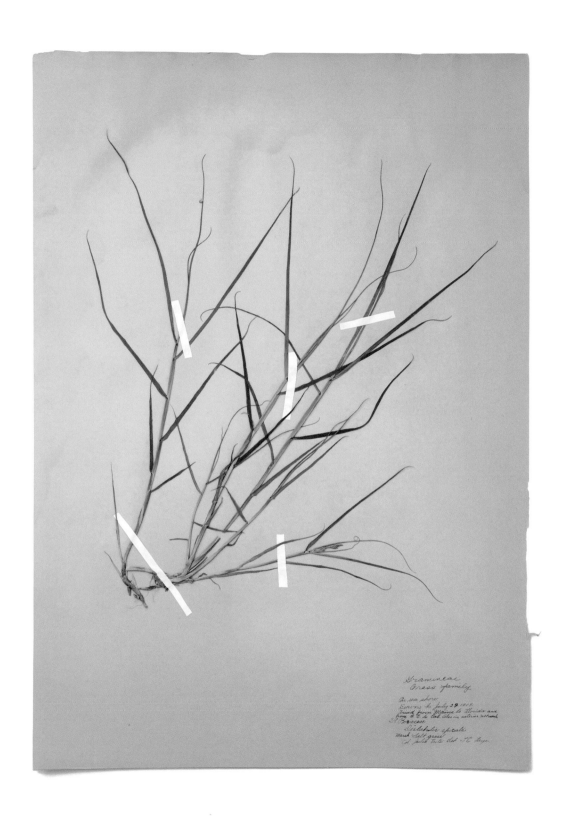

Exhibition Checklist

All works in the exhibition courtesy of the artist and Elizabeth Leach Gallery, Portland, Oregon, unless otherwise noted. Dimensions are given in inches; height precedes width.

Bone Stories
1992-1998

Black Crocs
1992
Selenium-toned gelatin silver print
24 x 20, edition six of six

Twelve Cats
1992
Selenium-toned gelatin silver print
50 x 40, edition five of six
Collection of George Stroemple

Dog Skull
1993
Selenium-toned gelatin silver print
20 x 16, edition one of five

To Kate
1994
Selenium-toned gelatin silver print
20 x 16, edition four of ten

Owl Kill
1995
Selenium-toned gelatin silver print
50 x 40, edition four of six

Pelican
1998
Selenium-toned gelatin silver print
20 x 8, edition one of two

Grids
1993

Grid 1
Selenium-toned gelatin silver print
16 x 20, artist's proof, edition of seven
Collection of Alexandra Hart

Grid 4
Selenium-toned gelatin silver print
16 x 20, artist's proof, not editioned
Collection of Alexandra Hart

Grid 5
Selenium-toned gelatin silver print
16 x 20, artist's proof, edition of one
Collection of Alexandra Hart

Grid 9
Selenium-toned gelatin silver print
16 x 20, artist's proof, edition of one
Collection of Alexandra Hart

Grid 11
Selenium-toned gelatin silver print
16 x 20, artist's proof, edition of one
Collection of Alexandra Hart

Grid 14
Selenium-toned gelatin silver print
16 x 20, artist's proof, edition of two
Collection of Alexandra Hart

Comparative Anatomy
1993

Aurelia
Selenium-toned gelatin silver print
24 x 20, edition two of seven

Bird Skulls
Selenium-toned gelatin silver diptych
20 x 34, edition one of three

Bones of Front and Hind Foot, and Teeth
Selenium-toned gelatin silver diptych
20 x 34, edition one of two

Feathers of Great Blue Heron
Cibachrome diptych
40 x 64, edition one of six
Collection of Carla and Sam Pope

Mandibles of Cats
Selenium-toned gelatin silver diptych
20 x 34, edition one of one

Raven Skull
Selenium-toned gelatin silver diptych
20 x 34, edition eight of twelve

Shark Teeth
Selenium-toned gelatin silver diptych
20 x 34, edition one of one

Untitled
Selenium-toned gelatin silver diptych
20 x 34, edition one of three

Cartwheel Suite
1995

Cartwheel 1
Selenium-toned gelatin silver print
50 x 40, edition three of four

Cartwheel 2
Selenium-toned gelatin silver print
50 x 40, edition three of five

Cartwheel 3
Selenium-toned gelatin silver print
50 x 40, edition three of six

Cartwheel 4
Selenium-toned gelatin silver print
50 x 40, edition three of four

Cartwheel 5
Selenium-toned gelatin silver print
50 x 40, edition three of three

Cartwheel 6
Selenium-toned gelatin silver print
50 x 40, edition three of four

India Tigers
1995

India Tiger 1
Selenium-toned gelatin silver print
14 x 11, edition three of ten

India Tiger 3
Selenium-toned gelatin silver print
14 x 11, edition eleven of twenty

India Tiger 4
Selenium-toned gelatin silver print
14 x 11, edition two of six

India Tiger 5
Selenium-toned gelatin silver print
14 x 11, edition one of twenty-one

India Tiger 7
Selenium-toned gelatin silver print
14 x 11, edition five of ten

India Tiger 10
Selenium-toned gelatin silver print
14 x 11, edition three of eleven

Jack-in-the-Box
1996

Jack-in-the-Box 1
Selenium-toned gelatin silver print
24 x 20, edition one of three

Jack-in-the-Box 2
Selenium-toned gelatin silver print
24 x 20, edition one of two

Jack-in-the-Box 3
Selenium-toned gelatin silver print
24 x 20, edition one of five

Jack-in-the-Box 4
Selenium-toned gelatin silver print
24 x 20, edition one of two

Jack-in-the-Box 6
Selenium-toned gelatin silver print
24 x 20, edition one of two

Jack-in-the-Box 7
Selenium-toned gelatin silver print
24 x 20, edition one of two

Insecta
1996–1997

Insecta 1
Selenium-toned gelatin silver print
32 x 39, edition one of two

Insecta 3
Selenium-toned gelatin silver print
32 x 39, artist's proof, edition of four
Collection of Alexandra Hart

Insecta 6
Selenium-toned gelatin silver print
32 x 36, edition one of two

Insecta 7
Selenium-toned gelatin silver print
32 x 39, edition one of two

Inchoation
1998–2000

Corvus corax
Coffee-stained, selenium-toned gelatin silver print
10 x 8, edition one of five

Dasypus novemcinctus
Gold-toned gelatin silver print
10 x 8, edition one of nine

Didelphis virginiana 1
Sepia- and selenium-toned gelatin silver print
8 x 10, edition two of twenty

Didelphis virginiana 3
Sepia- and selenium-toned gelatin silver print
8 x 10, edition one of five

Equus caballus
Sepia- and selenium-toned gelatin silver print
8 x 10, edition two of nine

Felis silvestris
Coffee-stained, selenium-toned gelatin silver print
8 x 10, edition one of five

Lepidochelys olivacea
Gold- and selenium-toned gelatin silver print
8 x 10, edition one of four

Neurotrichus gibbsi
Selenium-toned gelatin silver print
8 x 10, edition one of four

Raja binoculata
Gold-toned gelatin silver print
10 x 8, edition three of ten

Sus scrofa
Gold- and selenium-toned gelatin silver print
8 x 10, edition one of eight

Celebration Quartet
2004

Celebration 1
Pigment inkjet print on cotton rag paper
34 x 24, edition five of fifteen

Celebration 2
Pigment inkjet print on cotton rag paper
34 x 24, edition two of fifteen

Celebration 3
Pigment inkjet print on cotton rag paper
34 x 24, edition five of fifteen

Celebration 4
Pigment inkjet print on cotton rag paper
34 x 24, edition three of fifteen

Cors Mortale
2004

C. altivolum
Pigment inkjet print on cotton rag paper
24 x 18, edition one of fifteen

C. deliciae
Pigment inkjet print on cotton rag paper
24 x 18, edition one of fifteen

C. eruptionis
Pigment inkjet print on cotton rag paper
24 x 18, edition one of fifteen

C. fragile
Pigment inkjet print on cotton rag paper
24 x 18, edition one of fifteen

C. laceratum
Pigment inkjet print on cotton rag paper
24 x 18, edition one of fifteen

C. livorum
Pigment inkjet print on cotton rag paper
24 x 18, edition one of fifteen
Collection of Greg Kornberg

C. minimum
Pigment inkjet print on cotton rag paper
24 x 18, edition one of fifteen

C. perfectum
Pigment inkjet print on cotton rag paper
24 x 18, edition one of fifteen

C. plagatum
Pigment inkjet print on cotton rag paper
24 x 18, edition one of fifteen

C. pulsum
Pigment inkjet print on cotton rag paper
24 x 18, edition one of fifteen

C. sanctum
Pigment inkjet print on cotton rag paper
24 x 18, edition one of fifteen

C. vigoratum
Pigment inkjet print on cotton rag paper
24 x 18, edition one of fifteen
Collection of Greg Kornberg

Evidence of Its Occurrence
2004-2005

Evidence
Pigment inkjet print on cotton rag paper
24 x 18, edition one of fifteen

A. marginata
Pigment inkjet print on cotton rag paper
32 x 24, edition three of fifteen

C. ruprechtiana
Pigment inkjet print on cotton rag paper
24 x 32, edition three of fifteen

Ceraminales
Pigment inkjet print on cotton rag paper
24 x 32, edition one of fifteen

Codium
Pigment inkjet print on cotton rag paper
24 x 32, edition three of fifteen

F. endentatus
Pigment inkjet print on cotton rag paper
38 x 12, edition one of fifteen

G. lanceola
Pigment inkjet print on cotton rag paper
38 x 12, edition two of fifteen

L. bullata
Pigment inkjet print on cotton rag paper
24 x 32, edition four of fifteen

Laminaria
Pigment inkjet print on cotton rag paper
64 x 24, edition one of fifteen
Collection of Steven McGeady and Linda Taylor

N. latissimum
Pigment inkjet print on cotton rag paper
32 x 24, edition one of fifteen

N. leutkeana 1
Pigment inkjet print on cotton rag paper
32 x 24, edition six of fifteen

N. leutkeana 2
Pigment inkjet print on cotton rag paper
32 x 24, edition four of fifteen

Porphyra
Pigment inkjet print on cotton rag paper
32 x 24, edition three of fifteen
Collection of Steven McGeady and Linda Taylor

R. pertusa
Pigment inkjet print on cotton rag paper
24 x 32, edition one of fifteen

Rhodymenia
Pigment inkjet print on cotton rag paper
32 x 24, edition one of fifteen

S. gaudichaudii
Pigment inkjet print on cotton rag paper
32 x 24, edition three of fifteen

Undetermined
Pigment inkjet print on cotton rag paper
24 x 38, edition two of fifteen

Open Places
2007

Alpine Butterweed
Pigment inkjet print on cotton rag paper
24 x 17, edition one of fifteen

Buttercup
Pigment inkjet print on cotton rag paper
24 x 17, edition one of fifteen

Chestnut
Pigment inkjet print on cotton rag paper
24 x 17, edition one of fifteen

Cotton Grass
Pigment inkjet print on cotton rag paper
24 x 17, edition one of fifteen

Horsetail
Pigment inkjet print on cotton rag paper
24 x 17, edition three of fifteen

Marsh Salt Grass
Pigment inkjet print on cotton rag paper
24 x 17, edition three of fifteen

Onion
Pigment inkjet print on cotton rag paper
24 x 17, edition one of fifteen

Pathfinder
Pigment inkjet print on cotton rag paper
24 x 17, edition one of fifteen

Shepherd's Purse
Pigment inkjet print on cotton rag paper
24 x 17, edition one of fifteen

Smartweed
Pigment inkjet print on cotton rag paper
24 x 17, edition one of fifteen

Water Buttercup
Pigment inkjet print on cotton rag paper
24 x 17, edition one of fifteen

Professional History

Born 1945
Chicago, Illinois

Education

1970
University of Indiana, MFA in Painting

1967
University of Washington, BFA in Painting

Fellowships and Awards

2007
Professor Emerita, Pacific Northwest College of Art
Commissioned Awards Artist, Oregon Governor's
Art Awards

2005
Sara Roby Award for Teaching, Pacific Northwest
College of Art

2004
Artist Residency, University of Washington Friday
Harbor Laboratories, San Juan Island, Washington

2003
Artist Residency, University of Washington Friday
Harbor Laboratories, San Juan Island, Washington

2001
Artist Residency, Sitka Center for Art and Ecology,
Otis, Oregon

1987
Individual Artist Fellowship, Oregon Arts Commission
Artist Grant, Portland Photographic Forum

Museum Collections

International Center of Photography, New York City
Museo del Art Costarricense, San Jose, Costa Rica
Museu da Gravura Cidade, Curitiba, Brazil
Museum of Fine Arts, Houston, Texas
Portland Art Museum, Portland, Oregon
Princeton University Art Museum, Princeton,
New Jersey
Seattle Art Museum, Seattle, Washington

Selected Public and Institutional Collections

American Embassy, Belize
Burden Corporation, New York City
Meyer Memorial Trust, Portland, Oregon
New Photographics Permanent Collection, Central
Washington University, Ellensburg, Washington
Regional Arts & Culture Council, Portland, Oregon
State of Oregon Public Art Collection

Solo Exhibitions

2007
Field Notes, retrospective exhibition, The Art Gym,
Marylhurst University, Marylhurst, Oregon
Open Places, Elizabeth Leach Gallery, Portland,
Oregon
Out-of-Print, Elizabeth Leach Gallery, Portland,
Oregon

2005
The Marine Algae Project, Elizabeth Leach Gallery,
Portland, Oregon

2002
Herbarium, Savage Fine Art, Portland, Oregon

2000
Inchoation, S. K. Josefsberg Studio, Portland, Oregon

1998
Catlin Gabel School, Portland, Oregon
Insecta, *Insectary*, *Landscapes*, S. K. Josefsberg Studio,
Portland, Oregon

1997
Sticks, Stones, Bugs, and Bones, G. Ray Hawkins Gallery,
Los Angeles, California

1996
India Tigers, Nohra Haime Gallery, New York City
Jack-in-the-Box, *Luciana*, *Insecta*, S. K. Josefsberg
Studio, Portland, Oregon

1995
Cartwheel Suite, *India Tigers*, Savage Fine Art, Portland,
Oregon

1994

Art in the Governor's Office, Salem, Oregon

Bone Stories, Comparative Anatomy, Nohra Haime Gallery, New York City

1993

Bone Stories, Grids, Comparative Anatomy, Elizabeth Leach Gallery, Portland, Oregon

Bone Stories, Grids, Comparative Anatomy, Mid-Columbia Regional Arts Council, Richland, Washington

1989

Creative Art Gallery, St. Louis, Missouri

1988

E. J. Bellocq Gallery, Ruston, Louisiana

1987

Dillingham Center for the Performing Arts, Ithaca College, Ithaca, New York

Photographic Image Gallery, Portland, Oregon

SoHo Photo, New York City

1986

Camerawork Gallery, Portland, Oregon

Sunspot Gallery, College of Southern Idaho, Twin Falls, Idaho

1985

Mind's Eye Gallery, Idaho State University, Pocatello, Idaho

Renshaw Gallery, Linfield College, McMinnville, Oregon

1982

Camerawork Gallery, Portland, Oregon

Selected Group Exhibitions

2006

New Acquisitions, Portland Art Museum, Portland, Oregon

2004

Decade: 1994–2004, S. K. Josefsberg Studio, Portland, Oregon

Pixel Re(s)volution, Visual Arts Center Gallery, Mt. Hood Community College, Gresham, Oregon

2003

Core Sample, Symbiont/Synthetic, curated by Jeff Jahn, Portland, Oregon

Work by New Means: Recent Digital Photographic Prints, Portland Art Museum, Portland, Oregon

2002

Learning to Look: Photographs from the Ronna and Eric Hoffman Collection, Ronna and Eric Hoffman Gallery of Contemporary Art, Lewis & Clark College, Portland, Oregon

2001

Exposure, Zolla/Lieberman Gallery, Chicago, Illinois

Northwest Photography, House of Photography, Prague, Czech Republic

Six-Point Perspective, Holter Museum of Art, Helena, Montana

2000

EscapeLand, Zolla/Lieberman Gallery, Chicago, Illinois

Oregon's 20th Century in Photography, Portland Art Museum, Portland, Oregon

1999

Beauty in the Beast, Maryhill Museum, Maryhill, Washington

The End, biennial exhibition, Tacoma Art Museum, Tacoma, Washington

Portland Photographers, S. K. Josefsberg Studio, Portland, Oregon

Selections from the Jay Goodkind Collection, Princeton University Art Museum, Princeton, New Jersey

1997

Contemporary Photographs from the Permanent Collection, Princeton University Art Museum, Princeton, New Jersey

The Garden Show, curated by Victoria Beal, Portland Institute for Contemporary Art, Portland, Oregon

Observation and Invention: Oregon Women Photographers 100 Years After the Photo-Secession, The Art Gym, Marylhurst University, Marylhurst, Oregon

Oregon Biennial, Portland Art Museum, Portland, Oregon

Works on Paper, with Paper, and Drawings by Gallery Artists, Nohra Haime Gallery, New York City

1996

Nohra Haime Gallery, New York City

Raven: Icons and Omens, Fisher Gallery, Cornish College of the Arts, Seattle, Washington

XV Anniversary Show, Elizabeth Leach Gallery, Portland, Oregon

1995

Oregon Biennial, Portland Art Museum, Portland, Oregon

Stories: Narrative and Sequence in the Graphic Arts, Seattle Art Museum, Seattle, Washington

1994

RE-presenting the Object, The Art Gym, Marylhurst University, Marylhurst, Oregon

1993

Crosscut: Centennial Invitational Exhibition of Oregon Artists, Portland Art Museum, Portland, Oregon

The Vision at the End of the Trail: A History of Oregon Photography, Portland Art Museum, Portland, Oregon

1992

Scale Shift, Elizabeth Leach Gallery, Portland, Oregon

1991

10,000 Eyes, International Center for Photography, New York City

Still Life / Tableaux, Elizabeth Leach Gallery, Portland, Oregon

1990

Hand-altered Photographs, Elizabeth Leach Gallery, Portland, Oregon

Northwest Photographic Invitational, Maude Kerns Gallery, Eugene, Oregon

1989

Artquake, Performing Arts Center, Portland, Oregon

Field and Stream, Pritchard Gallery, Moscow, Idaho, and Boise Art Museum, Boise, Idaho

1988

Artquake, Performing Arts Center, Portland, Oregon

The Dead Animal Show, CAGE Gallery, Cincinnati, Ohio

1987

Additions to the Permanent Collection, Portland Art Museum, Portland, Oregon

Crosscurrents: Experimental Visions in Photography, Herrett Art Museum, Twin Falls, Idaho

Kanto Gakuin University, Yokahama, Japan

New Photographics / 87, Central Washington University, Ellensberg, Washington

Still Life Exhibition, Scheinbaum & Russek Gallery, Santa Fe, New Mexico

1986

Artquake, Portland Art Museum, Portland, Oregon

House and Garden Show, Blue Sky Gallery, Portland, Oregon

New Photographics / 86, Central Washington University, Ellensburg, Washington

Northwest Photographers, University of Montana, Bozeman, Montana

1985

Artquake, Portland Art Museum, Portland, Oregon

Northwest Photographers, Maltwood Gallery, University of Victoria, British Columbia, Canada

1984

First Annual Northwest Vision, University of Oregon Museum of Art, Eugene, Oregon

Gender Construction, Handwerker Gallery, Ithaca College, Ithaca, New York

Kanto Gakuin University, Yokahama, Japan

Water, Blue Sky Gallery, Portland, Oregon

Selected Bibliography

Aletti, Vince, "Voice Choices," *The Village Voice*, February 8, 1995

Allan, Lois, *Contemporary Art in the Northwest*, Craftsman House with G & B Arts International, 1995

————, "Dianne Kornberg at Savage Fine Art," *Artweek*, July 1995

————, "Dianne Kornberg at Elizabeth Leach Gallery," *Reflex Magazine*, July 1993

Borum, Ann Clements, editor, *10,000 Eyes*, Eastman Kodak Co. and Tommasson-Grant, 1991

Bullis, Douglas, *100 Artists of the West Coast*, Schiffer Publishing, 2003

Duckler, Garrick, "The Present Past, The Vision at the End of the Trail: A History of Oregon Photography at the Portland Art Museum," *Artweek*, January 1993

Dubinski, Allison, "Beauty in Biology," *Pacific Northwest College of Art BFA Catalogue, 2005–2006*, Plazm Publishing, Portland, Oregon

Ellison, Victoria, "A Macabre but Moving Mortality," *The Oregonian*, November 8, 1996

Francis, Kevin, "Is It Art?" *Willamette Week*, February 9-15, 1994

Frascella, Larry, "Portfolio: Dianne Kornberg, Portland, Oregon," *Photo/Design Magazine*, May–June 1988

Gallivan, Joseph, "Punk Is Showing Up All Over," *Portland Tribune*, January 10, 2007

Gragg, Randy, "Dianne Kornberg Takes Anatomy Series to New York," *The Oregonian*, January 1, 1994

Guthrie, Danny, *Gender Construction*, exhibition catalogue, Handwerker Gallery, Ithaca College, Ithaca, New York, 1984

Hays, Johanna, *Field & Stream: 16 Pacific Northwest Artists*, exhibition catalogue, Prichard Art Gallery, University of Idaho, February 1989

Hopkins, Terri M., *Observation and Invention: Oregon Women Photographers 100 Years After the Photo-Secession*, The Art Gym, Marylhurst University, September 1997

————, *Re-presenting the Object: Evidence, Notes, and Observations*, exhibition catalogue, The Art Gym, Marylhurst University, Marylhurst, Oregon, January 1995

Jahn, Jeff, "Symbiont/Synthetic," *Core Sample: Portland Art Now*, exhibition catalogue and DVD, Clear Cut Press, Astoria, Oregon, 2004

Jensen, Brooks, portfolio of reproduction gelatin silver prints, *Lens Work Reproductions*, 1998

————, portfolio of *Jack-in-the-Box*, *Lens Work Quarterly*, No. 16, Winter 1996/97

Joyner, Hermon, and Kathleen Monaghan, *Focus on Photography*, Davis Publications, Inc., 2007

Kanjo, Kathryn, *Oregon Biennial 97*, exhibition catalogue, Portland Art Museum, Portland, Oregon 1997

Klein, Harriet, "Photographs by Dianne Kornberg and Sharon Harper," *Portland, OR—What's Going On*, www.digitalcity.com, October 3, 2002

Lowrey, Melissa, *Northwest Originals: Oregon Women and Their Art*, InUnison Publications, 1989

Rauschenberg, Christopher, *Eyes of a City: A City of Eyes, Portland Photography 1975–99*, portfolio on CD-ROM, Blue Sky Gallery, 2000

Raymond, Camela, "A Paradox of Morbidity, Life," *The Oregonian*, June 23, 2000

Raymond, Jonathan, "The Fantasies of Facts," *The Oregonian*, May 1, 1998

Ross, Terry, "Hung-Up and Left to Dry," *The Oregonian*, May 19, 1995

Roth, Evelyn, "Now and Then," *American Photographer*, September 1987

Row, D. K., "Flashes of Wonder and Recognition," *The Oregonian*, March 13, 2005

————, "Digital Frontier," *A&E*, *The Oregonian*, November 7, 2003

————, "Insects and Legends," *The Oregonian*, April 17, 1998

————, "Dianne Kornberg," *Willamette Week*, November 13, 1996

Toedtemeier, Terry, "Work by New Means: Recent Digital Photographic Prints," *Members' Magazine*, Portland Art Museum, Fall 2003

————, *Selected Works*, The Portland Art Museum, Portland, Oregon, 1996

Ward, Logan, "Hot Contemporary Photographers, Coast to Coast," *American Photo*, March/April 1997

Weinstein, Joel, editor, portfolio of *Cartwheel Suite*, *Mississippi Mud No. 38*, 1996

This book has been designed and produced by John Laursen at Press-22 in Portland, Oregon, during the summer of 2007. The typeface is Stone Serif. The 200-line color separations were created by Jim Haeger at Revere Graphics, and the printing was done by Millcross Litho on acid-free 100# Lustro Dull book paper. The edition is fifteen hundred books, Smythe-sewn and bound in cloth over boards by Lincoln and Allen. Sixty books contain an original print and have been bound with a leather spine and numbered and signed by the artist.